_THI RD_S PACE

/shifting conversations about contemporary art

Edited by

Wassan Al-Khudhairi

Contributions by

Wassan Al-Khudhairi

Ivy G. Wilson

H. G. Masters

Lindsey Reynolds

BIRMINGHAM MUSEUM OF ART

_THI
RD_S
PACE

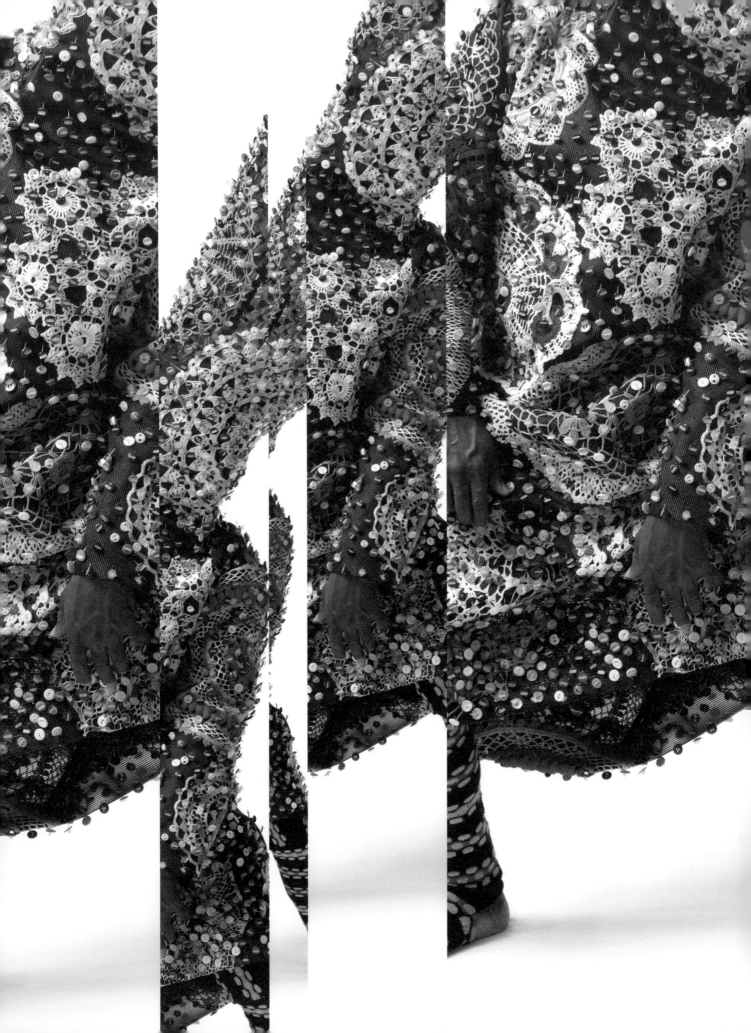

/contents

/dedication

In memory of our friend
and colleague Spencer Shoults

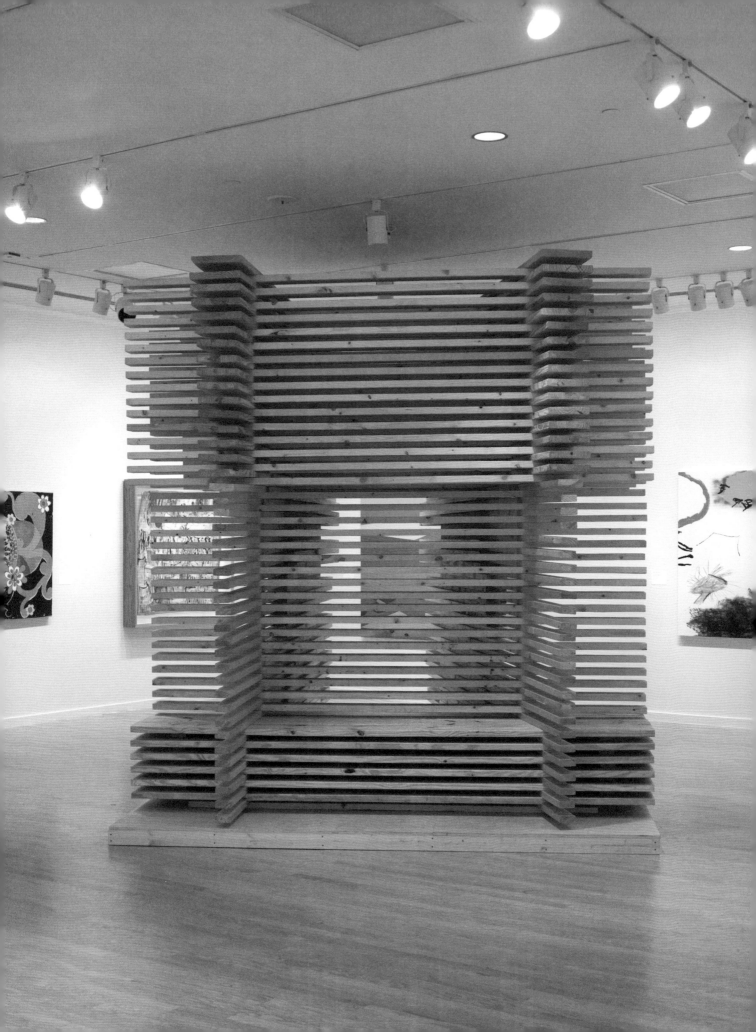

Gail C. Andrews
The R. Hugh Daniel Director

/director's foreword

Contemporary art is richly diverse, eliciting reactions as varied as the artists themselves. Works may touch our souls with their beauty and elegance, pierce our hearts through revelations of pain or injustice, or trigger our senses of humor and curiosity with irony and invention. But most important, the works often speak to our time, awakening us to new and different perspectives.

Knowing the value of seeing the art of our time and interacting with art and artists who may help us question assumptions and navigate differences through conversations, we were eager to place more of our collection of contemporary art on view and make it available to the public. Our gallery space dedicated to modern and contemporary art has not kept pace with the growth of the collection itself. Thus, the decision to create *Third Space,* a special exhibition of our contemporary collection housed in the larger, newly renovated Jemison galleries, has given us the opportunity to highlight the depth and breadth of our holdings in this area.

The collection itself is excellent, carefully built over time with thoughtful consideration and strategy. Its growth and caliber is due in large measure to the Collectors Circle for Contemporary Art, a group formed almost twenty-five years ago that is dedicated to the acquisition of contemporary art for the museum. The group is composed not just of individuals who are invested, but also of those who want to understand contemporary artists, what they are making, and why. Each year, as the membership grows, the Collectors Circle visits artists' studios, galleries, and museums, posing questions in an effort to better understand the world. The group has been a tremendous gift to the museum, our community, and the members themselves. Their willingness to take risks has paid strategic dividends, as they have purchased works that in many cases would be difficult

to acquire today. And their engagement has inspired a new community of collectors and contemporary art enthusiasts.

One of the unexpected joys in opening *Third Space* is witnessing members of the community so thrilled to see these objects on view again. By arranging the works in a way that inspires dialogue, Wassan Al-Khudhairi has masterfully curated an exhibition through which visitors may draw connections between the American South and the Global South. The themes of migration, identity, history, memory, and the environment, among others, offer profound ways to explore not only the links between the objects in this exhibition but also those among works of art across the museum's fine global collection, particularly with regards to questions resonating in the world today. Our intent, as always, is to offer an enlightening experience that invites close, thoughtful looking, and creates new or expanded knowledge and insights.

The museum is indebted to our funders, in particular PNC, Community Foundation of Greater Birmingham, Protective Life Foundation, and Vulcan Materials Company Foundation. I am also grateful to the talented and dedicated staff of the museum, all of whom played a role in the formation and realization of this exhibition.

GAIL C. ANDREWS THE R. HUGH DANIEL DIRECTOR

Wassan Al-Khudhairi

/curator's acknowledgments

Third Space would not have been possible without the support and assistance of a number of Birmingham Museum of Art staff, individuals, lenders, and galleries. I would first like to thank Gail Andrews, the R. Hugh Daniel Director, for her support and leadership. A big thanks to the contributors to this catalogue, Ivy G. Wilson, H. G. Masters, and Lindsey Reynolds. I continue to be inspired by the work produced by Rural Studio at Auburn University and am especially thankful to Xavier Vendrell and Stephen Long for their innovative ideas and willingness to take on the invitation to commission a work of art for the exhibition and to their students for building the sculpture. For her research and coordination, I am grateful to Isabel Barnes, who never stopped pouring her energy and passion into the exhibition. I am incredibly thankful to Dr. Emily Hanna for her advice and encouragement along the way and her scholarship in producing a number of interpretive materials. I would like to express my gratitude to Eric McNeal, Assistant Registrar, and Suzanne Stephens, Senior Associate Registrar, who were both integral in researching the artworks in the exhibition. James Williams, Creative Director, was essential to the development of the design of the exhibition in the galleries, online, and in print, and I am inspired by his designs and his willingness to take chances.

A big thanks goes to my colleagues at the Birmingham Museum of Art for their commitment to seeing the exhibition through from big picture to the minute details: Terry Beckham, Exhibitions Designer; Kristi Taft, Exhibitions Officer; Sean Pathasema, Director of Photography and Visual Services; Carmen Gonzalez Fraile, UAB Curatorial Fellow; Angela May, Docent and Tour Coordinator; Lindsey Hammel, Manager for Visitor and Volunteer Services; and Cate Boehm, Director of Marketing and Communications. Thank you to the prep team led by Priscilla Tapio, including Spencer Shoults, Ellen Ezekiel, Alex

McClurg, and Joe McCreary. Additional thanks goes to Margaret Burnham, Conservator, and Lisa Stewart, Collection Care Specialist.

Third Space includes several works of art from private collectors and I want to thank them for their continued generosity: Jim Sokol and Lydia Cheney, Sheldon Inwentash and Lynn Factor, Michael Straus, Tom L. Larkin, Doug McCraw, the Bjørnholt Collection, Jack and Rebecca Drake, Margaret and Bruce Alexander, Karen and Joel Piassick, and Norm and Carnetta Davis. A number of individuals and galleries supported the research and loans for the exhibition. My gratitude goes to David Moos, Caroline Taylor, Bill Brady Gallery, Barbara Chase-Riboud, Sue Williamson, Amy Plumb Oppenheim, and Anthony Abell/Image Hive.

Thank you to Kate Cleveland, Director of Development, for her leadership in raising the funds to make this exhibition come to fruition, as well as her team: Meghan Ann Hellenga, Claire Hubbs, Rebecca Schaller, and Nancy Cooper. *Third Space* is presented by PNC, with additional support from Community Foundation of Greater Birmingham, Protective Life Foundation, and Vulcan Materials Company Foundation. Funding was also provided by the Alabama State Council on the Arts and the National Endowment for the Arts, City of Birmingham, Robert R. Meyer Foundation, Luke 6:38 Foundation, Susan Mott Webb Charitable Trust, The Gladys Krieble Delmas Foundation, Robert Rauschenberg Foundation, Alabama Tourism Department, Alabama Humanities Foundation, the state affiliate of the National Endowment for the Humanities, and The Lydia Eustis Rogers Fund.

I appreciate the generous contributions toward the exhibition and publication from the Friends of *Third Space*. Sponsors include Dr. and Mrs. C. Bruce Alexander, Ms. Lydia Cheney and Mr. James D. Sokol, Jane S. Comer and Charles Lantz, Dr. and Mrs. Frederick J. Elsas, GCP / Graham Commercial Properties, Mr. and Mrs. John L. Hillhouse, Jr., Mr. and Mrs. Joel B. Piassick, The Straus Family Fund, and Mr. and Mrs. Robin A. Wade. Sustainers are Beverly and Stanley Erdreich, Ms. Dorothy Mitchell, Robin Morgan, Mr. and Mrs. James K. Outland, Mr. Michael Randman, Dr. and Mrs. David A. Skier. Benefactors are Mrs. Barbara Hirschowitz, Mary Lyn and David LaRussa and Dr. Lisa Mani. Supporters are AG Lighting, BIG Communications, Dr. and Mrs. Jon J. Blankenship, Dr. Graham C. Boettcher, Mr. and Mrs. William J. Cabaniss, Jr., Ms. Tammy D. Cohen and Mr. Richard G. Carnaggio, Mr. and Mrs. Russell J. Drake, Kaaren Hirschowitz Engel, Four Corners Gallery, Mr. Doug McCraw, Mrs. Shirley K. Osband, Mr. and Mrs. T. Alan Ritchie, Jr., and Ms. Tina Ruggieri and Mr. Scott

WASSAN AL-KHUDHAIRI

Miller. Additionally, thank you to our Patron and Friend level supporters who also gave generously.

Support for the Rural Studio commission was provided by ArchitectureWorks, Austin & Co, BLACKSHOP, David Baker Architects, Giattina Aycock Architecture Studio Inc., Scottie and Bruce Lanier, Long & Long Design, Lois and Jim Turnipseed, Pfeffer Torode, and Williams Blackstock Architects. We extend our deep appreciation to the students and faculty of Auburn University, Rural Studio.

This exhibition would not be possible without the continued support of the Collectors Circle for Contemporary Art.

Finally, I want to give my enormous gratitude to the creative community in Birmingham for its overwhelming support in embracing the exhibition and beginning a critical dialogue around the works of art and ideas in the exhibition.

/third space/ _shifting _convers ations_ about_ contempo rary_art

During the conceptualization of *Third Space* the political climate in the United States was experiencing a resurgence and hardening of binaries: a stronger pull to be "for" or "against" an issue with less and less space in which to navigate the middle. Stephanie Bailey describes the condition from a more global perspective: "In these hyper-global, hyper-connected, and hyper-volatile times, in which we have seen a new wave of neo-nationalism, regional power grabs, and the emergence of a networked movement in the nightmare image of ISIS, conversations around identity have become dangerously essentialist yet loaded with potential agency. Today, a politics based on difference offers a useful frame to think through the globalized present."[1] It is within this environment that the ideas for this exhibition began to develop—with a sense of urgency to create a space in which to explore a shared human experience and the possibilities for making connections via an in-between space, or Third Space.

The exhibition title is borrowed from Homi Bhabha, a postcolonial theorist who coined the term and defines it as a space that "challenges our sense of the historical identity of culture as a homogenizing, unifying force, authenticated by the originary Past, kept alive in the national tradition of the People."[2] Thus, *Third Space* attempts to open up a dialogue, to propose the possibility of connections between the American South and the Global South, rather than a

binary North/South discussion, in an attempt to explore a trilectic—a "third space."

Not defined by concrete geographical limits, the Global South is a concept that unites places with a past that defines their present. It is an imagined space that ties cultures together by their common experiences and considers the voices of people who are often unheard. Conversely, the American South, commonly referred to geographically as the states below the Mason-Dixon Line, is often discussed in relation to the North and within the confines of the United States. This project proposes a more horizontal perspective, one that connects the American South to other Souths across the globe. Thinking beyond geographical boundaries, the American and Global Souths similarly represent marginalized people and places that share common post-colonial heritage, similar patterns of migration, and cultural connections.

Using works from the Birmingham Museum of Art's permanent collection, *Third Space* creates the opportunity for the discovery of affinities among the two Souths. Some of these artworks make direct connections. For example, Sue Williamson's *Mementoes of District Six* (1993)—an installation that humanizes the total destruction of an entire area in South Africa during apartheid—proposes a parallel between the condition left behind as a result of apartheid and the result of segregation in the American South. Other works, such as the visual manifestations of identity in Beatriz Milhazes's and Juan Uslé's, make connections in a more conceptual manner. To frame the conversation and help visitors discover the possible analogies, the exhibition is loosely grouped into four sections, each under the heading of three interrelated words: *tradition/history/memory, representation/agency/gaze, landscape/nature/spirit*, and *migration/diaspora/exile*. These sections are in no way concrete and the word groupings are intended to propose tools for looking at the works of art and asking questions that help viewers arrive at their own conclusions. An emphasis is placed on the possibility for open-ended interpretations.

the souths

It is overwhelming to think about pushing together two monolithic terms like American South and Global South. Both are loaded concepts that can be interpreted in a multitude of ways depending on context and perspective. *Third Space* explores the artistic possibilities among the two terms. It offers an invitation to question how developments in Alabama and the American South can be

understood in the global context of equality and freedom, the exploitation of people and land, and identity and race relations. Beyond providing a space, the exhibition strives to also question what happens when equality is systematically extended across boundaries, therefore creating the opportunity for a transparent and open discussion.

Inspired by Koyo Kouoh's edition of EVA, Ireland's biennial, *Still (the) Barbarians*—which positioned Ireland "as a point of departure from where artistic reflections, critical redefinitions, and political transformations are articulated"—*Third Space* offers Birmingham and the American South as a starting point.[3] The summary of the Ireland exhibition resonates with the framework for *Third Space:* "look at the postcolonial condition on a comparative rather than a binary level . . . attempt to show that the local is in the global and that the global has an influence on the local, and how these contemporary issues are a matter of interdependency and similarities of processes of recovery from the colonial experience."[4] The Global South is also the focus of this year's Documenta in Kassel; however, a critical re-examination and re-positioning of the Global South has been circulating in the curatorial discourse for some time. Sharjah Biennial 11 in 2013, *Re:emerge, Towards a New Cultural Cartography,* uses Sharjah as a local departure point for re-mapping the Global South.[5]

Historically, Alabama played a pivotal role in the history of the United States as the center of the struggle for human and civil rights in the 1950s and '60s. It was a time when people around the world were fighting for equality and freedom, and Alabama contributed to this sweeping social change. In the catalogue for the recent exhibition *Southern Accent*, curators Miranda Lash and Trevor Schoonmaker begin with "the premise of the South as a question rather than an answer."[6] Lash's explanation of the American South is relevant for *Third Space* even though *Southern Accent* focuses on the American South within the confines of the United States:

"The South, or the southern part of the United States—depending on whom you ask—can evoke anything from distinct geographies and mannerisms to the way words are spoken and time is managed, from specific styles of cooking and music to particular relationships to history and tradition, to types of religious devotion. At its worst, the South is defined by poverty, poor education, conservatism, the legacy of slavery, and discrimination that can flare into brutal violence. In more positive iterations, the

South is associated with politeness, tight-knit families, soul food, devoted spirituality, and lush landscapes."[7]

Similarly, the Global South can also be many things at once. In *South as a State of Mind*, Nikos Papastergiadis writes, "I understand the concept of the South as a loose hemispheric term that refers to a series of plans that share similar patterns of colonisation, migration and cultural combinations. For me, the South is also expressive of a cultural imagination that looks outwards from its own national base, going against the grain of its colonial past."[8]

american south as post-colonial

"The colonized, underdeveloped man is
today a political creature in the most
global sense of the term."
—Frantz Fanon[9]

In a reprint of Frantz Fanon's *The Wretched of the Earth,* Homi Bhabha writes, "It is my purpose, almost half a century later to ask what might be saved from Fanon's ethics and politics of decolonization to help us reflect on globalization in our sense of the term."[10] My research for exploring the American South through a postcolonial lens was guided by the words and ideas of Fanon and Bhabha.

In proposing that both the Global South and the American South exist as post-colonial spaces one might question how the American South can be considered as such. Jon Smith, an associate professor at Simon Fraser University, argues that the South has experienced three types of colonialism. The first is "settler colonialism" in which settlers killed and displaced Native American communities across the South, further emphasizing the binary, black-white racial logic. Smith further emphasizes the erasure of Native Americans from their presence in the region by posing the question, "How many post-colonialists or Americanists know for certain from which water fountains Indians were allowed to drink?" Next, he suggests that the 1920s brought African American activists who perceived their struggle for civil rights as "part of a global decolonization movement on the part of peoples of color." Finally, Smith explains the 1880s perception of the Civil War and Reconstruction as imperial conquest. He quotes from a speech by University of Virginia president Edwin A. Alderman in 1908: "No other region among the great culture nations

ever lost in less than a decade over one-tenth of its population, three and a half billions of its wealth, the form of its society and the very genius of life, save a certain unconquerable courage and self-reliance." Using the same lens to analyze the American South as a post-colonial space, Smith proposes an analysis that is especially relevant in thinking about the present and the future: "With its history of colonial plantations, race slavery, race mixing, vibrant African cultural survival, disappeared bodies, a predilection for the baroque (as Alejo Carpentier defines it), poverty, state-sponsored right-wing terrorism, insular communities [and] creole nativism, the very South that now runs the world contains within itself residua—including a dangerous, narcissistic grandiosity—of its status as a Third World country."[11]

tradition/history/memory
migration/diaspora/exile

These sections of the exhibition address the post-colonial condition, offering visitors the opportunity to consider relationships between words and the works on display. *Tradition/history/memory* prompts the viewer to consider how history or the past can inform the future, then build on a future using past achievements. In times of difficulty, traditions, histories, and memories—the things that define communities—are often at risk of being erased, suppressed, or hidden. *Migration/diaspora/exile* explores the reality of people who leave their homelands, whether by choice or by force—often as the result of war, political turmoil, or slavery. Some leave home in search of a better life, others have no choice; however, wherever they go, they take with them their customs, traditions, identities, and cultures.

representation/agency/gaze
landscape/nature/spirit

Both the American South and the Global South suffer from being viewed as "the other." As Stuart Hall describes it, "This 'look,' from—so to speak—the place of the Other, fixes us, not only in its violence, hostility and aggression, but in the ambivalence of its desire. This brings us face to face, not simply with the dominating European presence as the site or 'scene' of integration where those other presences which it had actively disaggregated were recomposed—re-framed, put together in a new way; but as the site of a profound

splitting and doubling—what Homi Bhabha has called 'the ambiva-
lent identifications of the racist world... the 'otherness' of the self-
inscribed in the perverse palimpsest of colonial identity."[12] This is
manifested in both contexts of the Souths, and in *Third Space* these
ideas are further explored by the works in the sections *representation/
agency/gaze* and *landscape/nature/spirit*.

 Third Space aims to create a place where all voices and perspec-
tives are equally valued. A work central to the exhibition represents
a culmination of all the ideas in the exhibition. It was commissioned
from Rural Studio at Auburn University. Based in Hale County,
Alabama, in the Black Belt, which is considered one of the poorest
counties in the country, Rural Studio is one of the leading design-
build architecture programs. Their approach to architecture is one
that concerns the responsible use of resources and serving the
immediate community through architectural projects. For *Third
Space*, Acting Director Xavier Vendrell and Professor Stephen Long
created a sculpture titled *2x's* (2016), which takes its inspiration from
Rural Studio's 20K home, a project that started in 2005 to respond to
the lack of affordable housing for people living under government
subsidy. All labor and building materials for the 20K project are pro-
cured locally, helping to fuel the local economy, particularly the lum-
ber industry, which is a major force in Alabama. In turn, the principal
material used in the project is pine, which serves as the structure for
each house, a part that is hidden in its rough state and not intended
to be seen. The sculpture is composed of the exact amount of lum-
ber in quantity and dimension that it took to build Dave's Home, one
of the early iterations of the 20K project. For the construction of this
sculpture, the lumber was not cut or manipulated, and only screws
were used to connect the pieces; thus, after the exhibition ends the
sculpture will be disassembled and the lumber will be transported
to Hale County to be used in the building of a 20K home. This rep-
resents the cyclical nature of materials and using architecture as a
form of activism.

 Third Space from its inception was an exhibition that proposed
using Birmingham and the region of the American South as a start-
ing point for looking out into the world. Critically thinking about the
context of the American South while looking beyond the region
enabled the search for possibilities of a shared human experience.
The exhibition does not claim to make definite analogies but aims to
propose suggestions, connections, and similarities. It places the
audience in the position of drawing their own conclusions, prompting
each visitor to ask questions of the works of art with the assertion

that individual perspectives and experiences allow for the discovery of a variety of connections. The affinities among the works—and among the American South and Global South—are activated by the presence of the visitor.

notes

1 Stephanie Bailey, "Be Here, Now: An Introduction to an Introduction," *LEAP The International Art Magazine of Contemporary China* 1/2 (January/February 2016): 48.

2 Homi K. Bhabha, "Cultural Diversity and Cultural Differences," in *The Post-Colonial Studies Reader*, ed. B. Ashcroft, G. Griffiths, and H. Tiffin (New York: Routledge, 2006), 155–57.

3 Aoife Rosenmeyer, "Where the Barbarians Are: A Conversation with Koyo Kouoh," *Art in America,* April 13, 2016, http://www.artinamericamagazine.com/news-features/interviews/where-the-barbarians-are-a-conversation-with-koyo-kouoh/.

4 Stephanie Bailey, "Still (the) Barbarians: Koyo Kouoh in Conversation with Stephanie Bailey," IBRAAZ, July 28, 2016, http://www.ibraaz.org/interviews/200.

5 "Going Both Ways: Yuko Hasegawa in Conversation with Walter D. Mignolo and Stephanie Bailey," IBRAAZ, May 2013, http://www.ibraaz.org/interviews/79.

6 Miranda Lash and Trevor Schoonmaker, eds., *Southern Accent: Seeking the American South in Contemporary Art* (Durham: Nasher Museum of Art at Duke University, 2016), 19.

7 Ibid.

8 Nikos Papastergiadis, "What is the South?," *South as a State of Mind*, no. 1 (Summer 2012): 27.

9 Frantz Fanon, *The Wretched of the Earth,* trans. Richard Philcox (New York: Grove Press, 2004), 40.

10 Ibid, xi.

11 Jon Smith, "The U.S. South and the Future of the Postcolonial," *The Global South* 1, no. 1 (Winter 2007): 153–58.

12 Stuart Hall, "Cultural Identity and Diaspora," in *Identity: Community, Culture, and Difference*, ed. Jonathan Rutherford (London: Lawrence and Wishart Ltd.), 233.

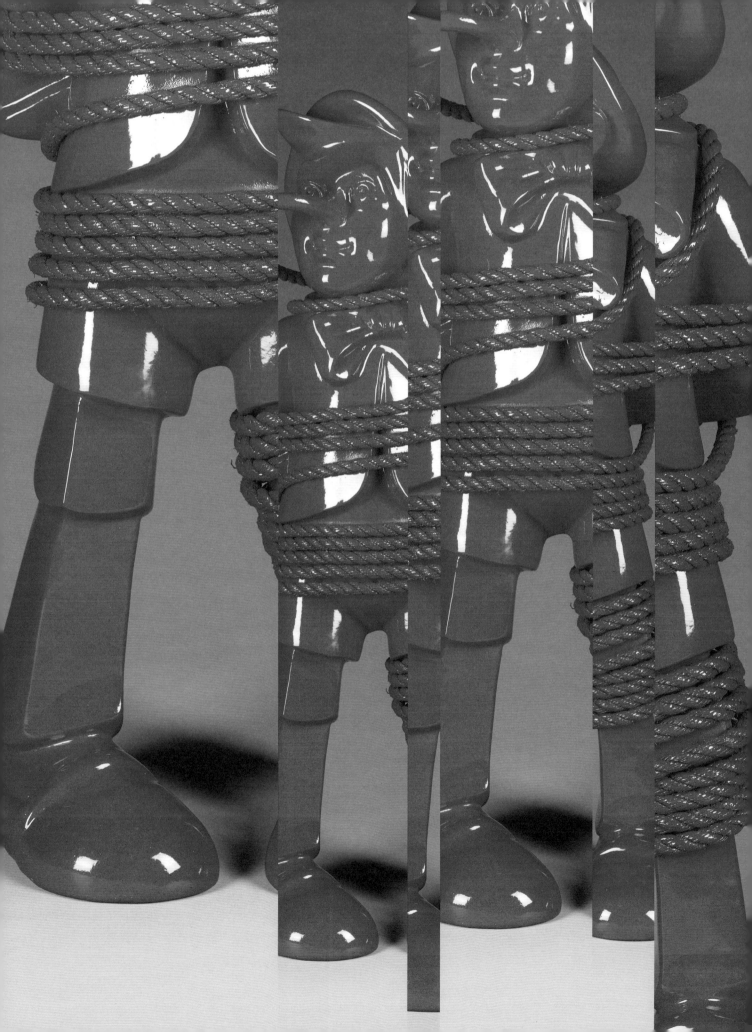

/migr
ation
dias
pora
exile

ENRIQUE CHAGOYA
with Alberto Ríos
You Are Here, 2000

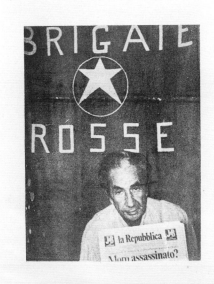

SARAH CHARLESWORTH

April 21, 1978, 1978

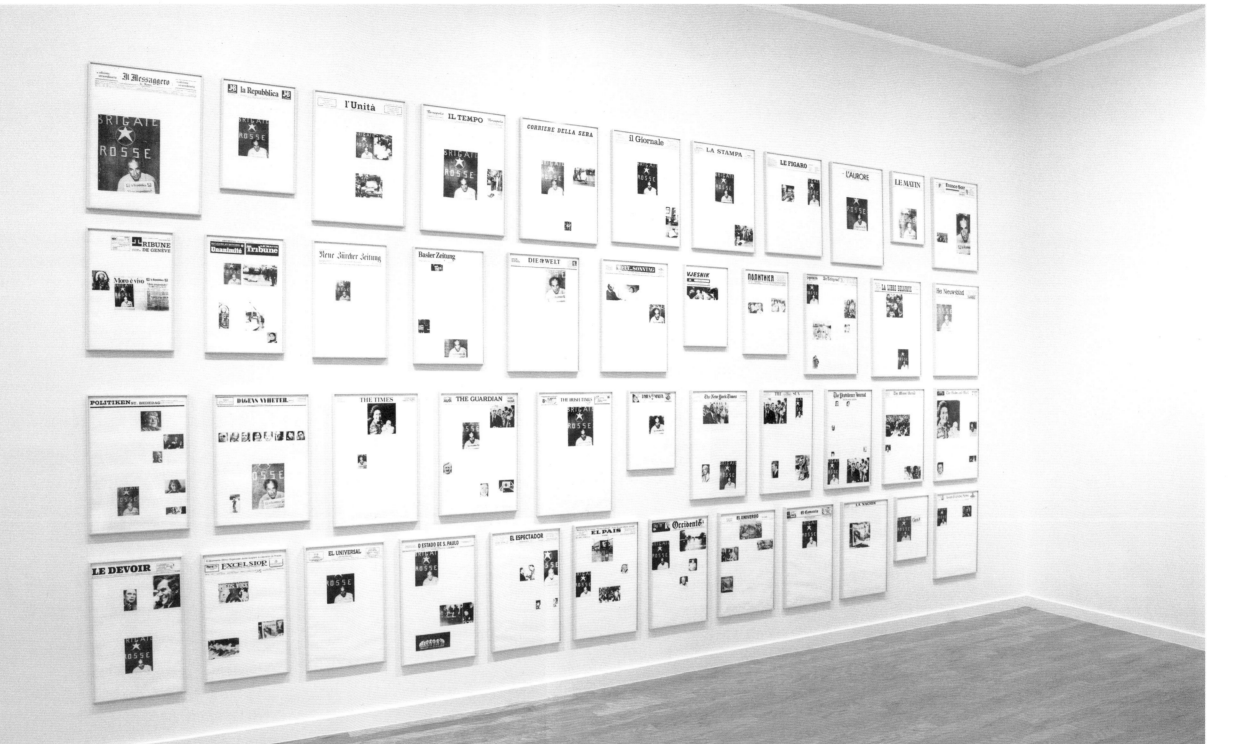

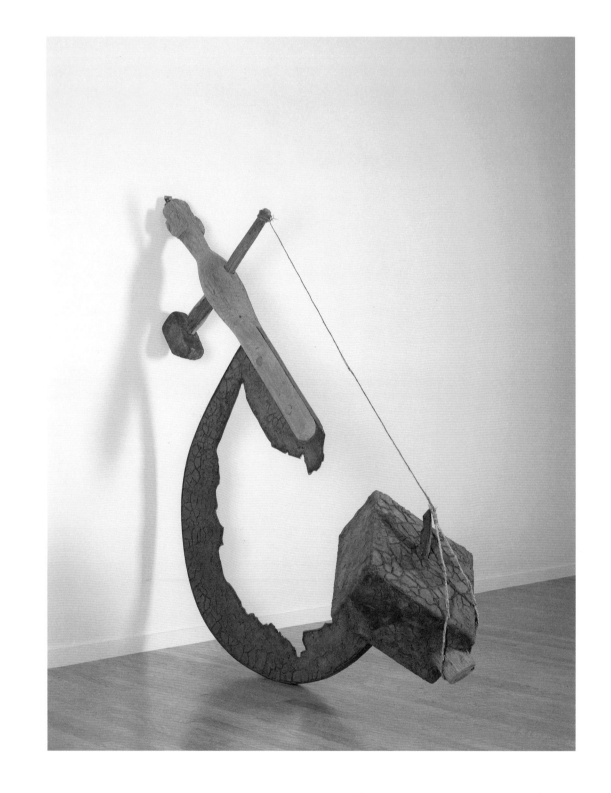

MEL CHIN
The Sigh of the True Cross, 1988

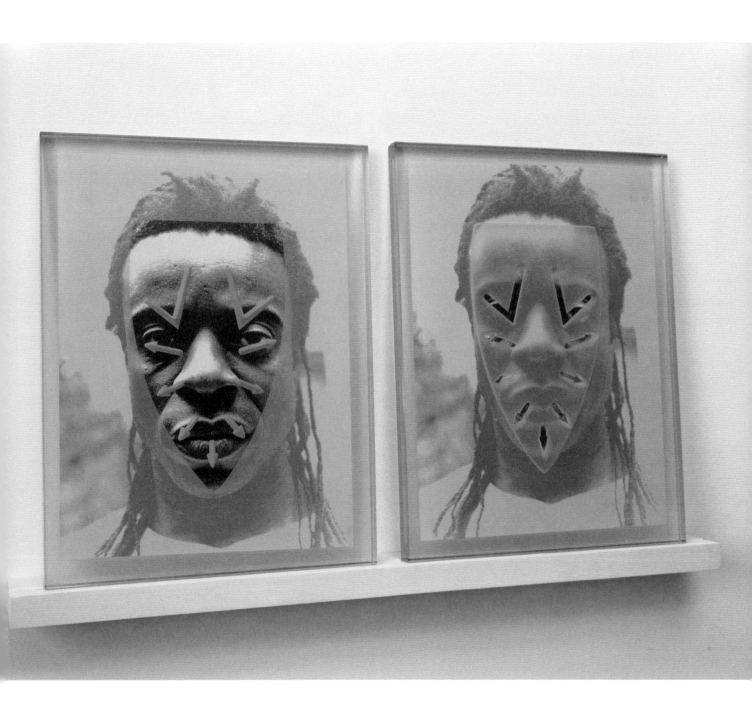

WILLIE COLE
G.E. Mask and Scarification, 1998

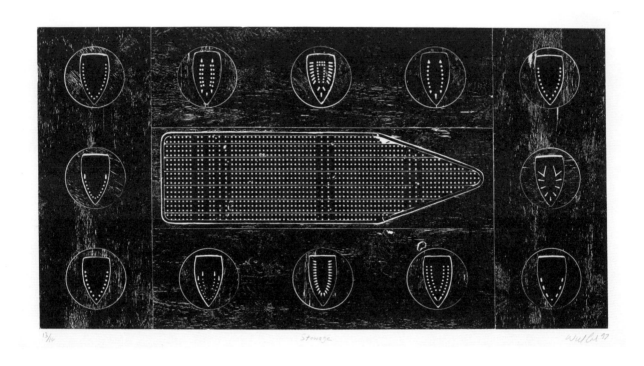

WILLIE COLE
Stowage, 1997

30

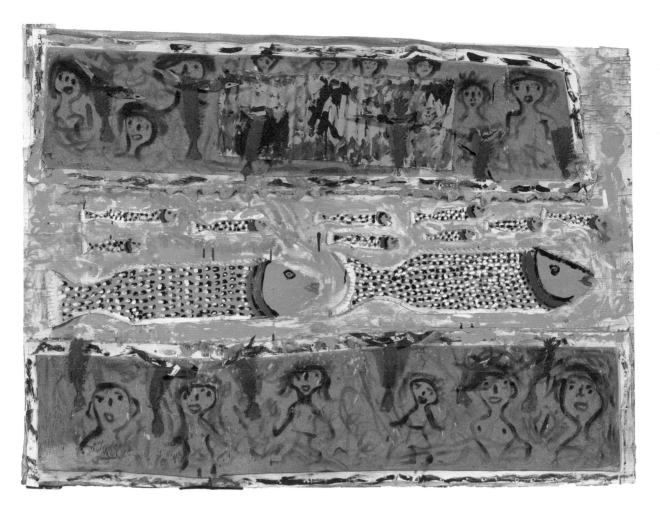

THORNTON DIAL
Big Fish Eat All the Little Fish, About 1983

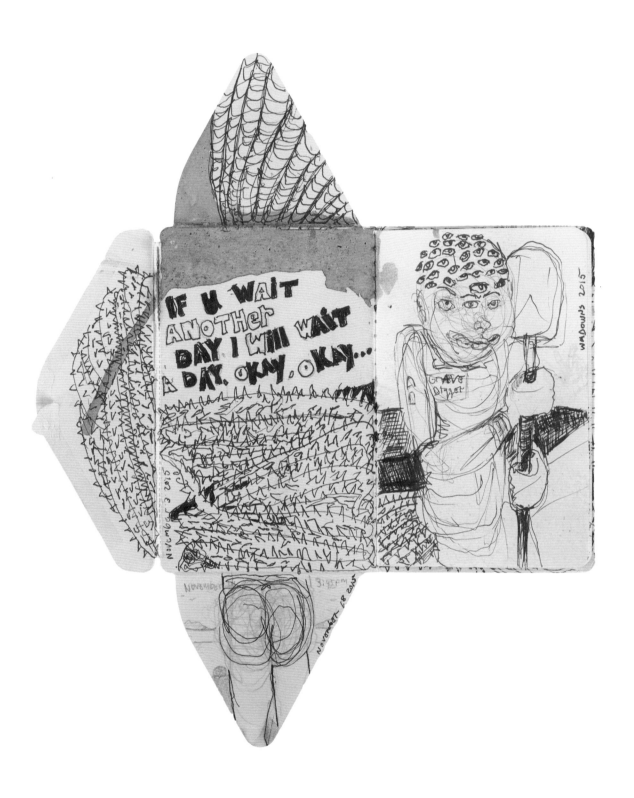

WILLIAM DOWNS
I will wait another day, 2015

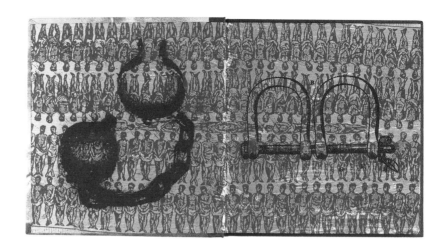

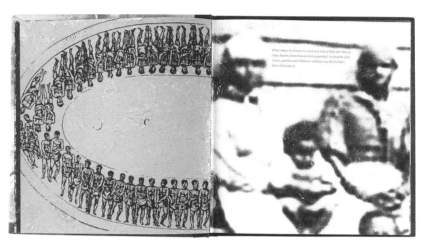

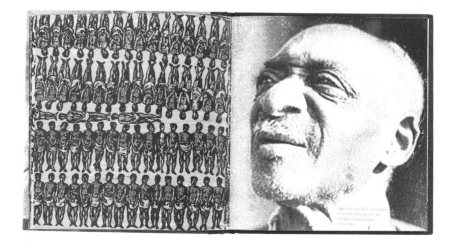

FRED HAGSTROM
Passage, 2013

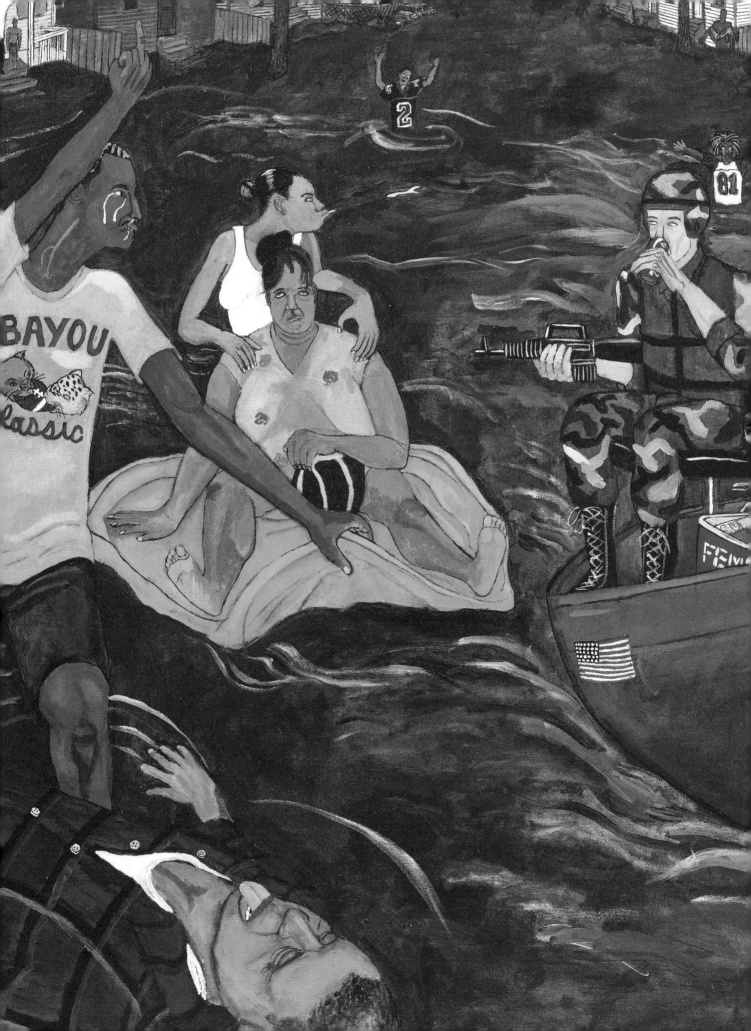

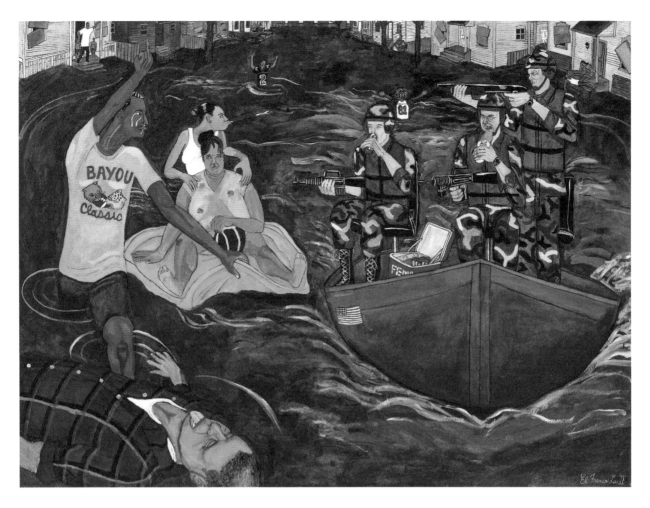

EL FRANCO LEE II
Nightmare Katrina 2, 2006

MICHAEL RAKOWITZ
Sabreen: Live in Jerusalem 2010, 2014

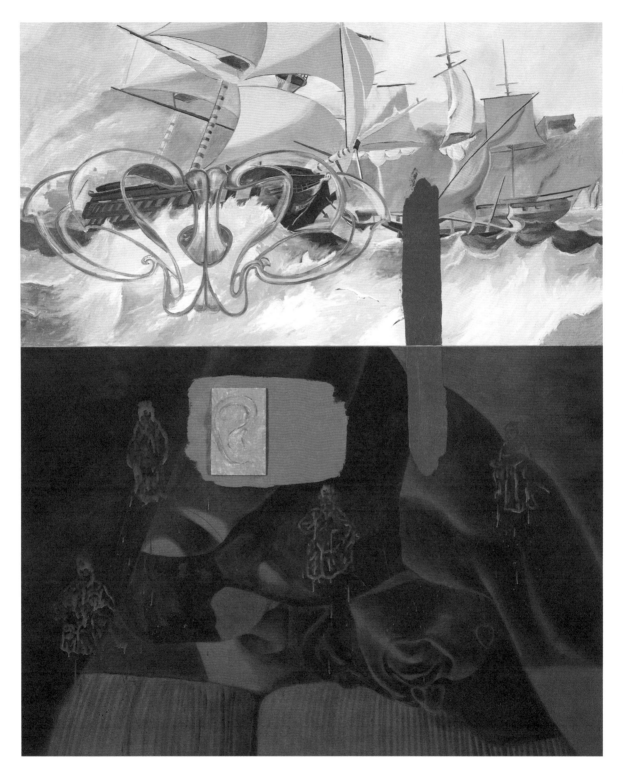

DAVID SALLE
Making the Bed, 1985

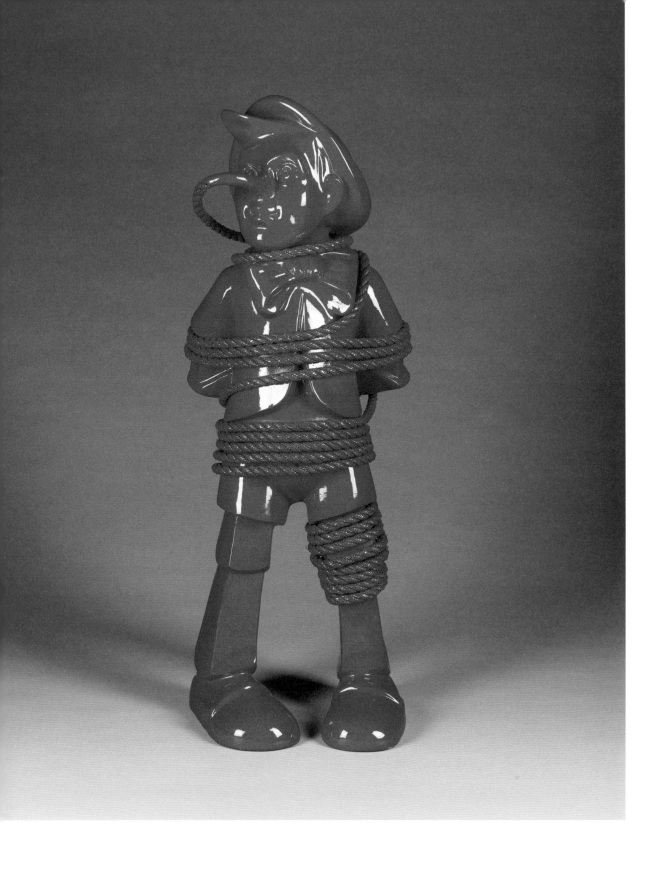

ESTERIO SEGURA
La historia se muerde la cola (History Bites its Tail), 2013

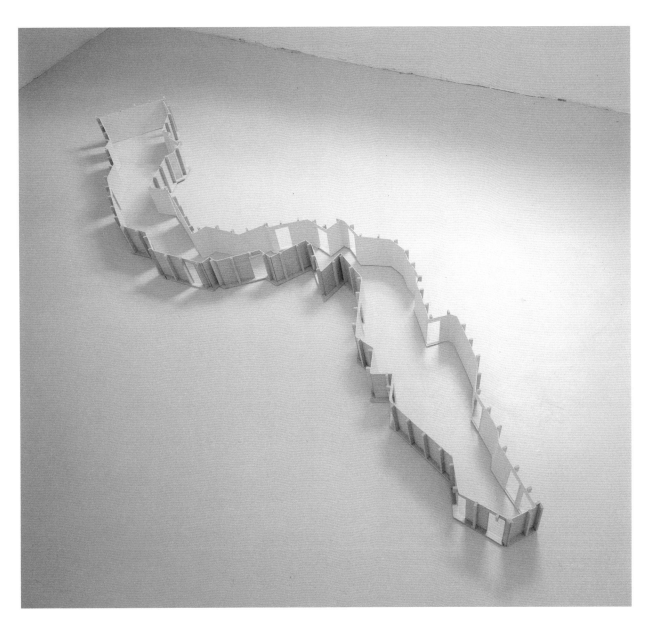

KATRÍN SIGURDARDÓTTIR
2nd Floor (784 Columbus Ave), 2003

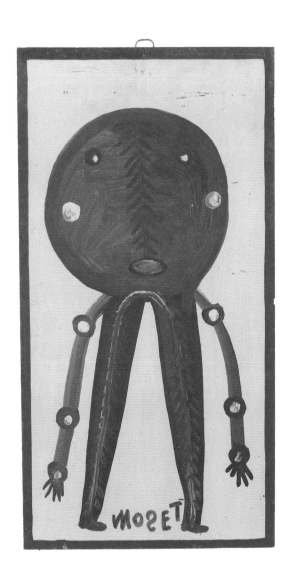

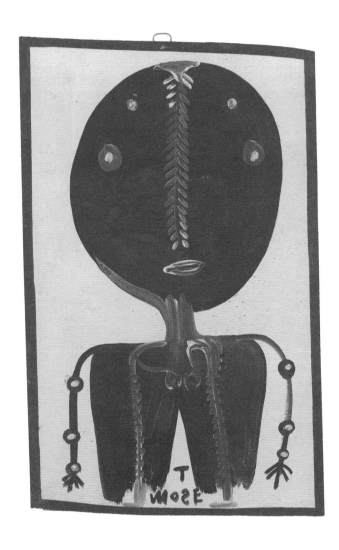

MOSE TOLLIVER
Dry Bones, 1985

MOSE TOLLIVER
Dry Bones, 1985

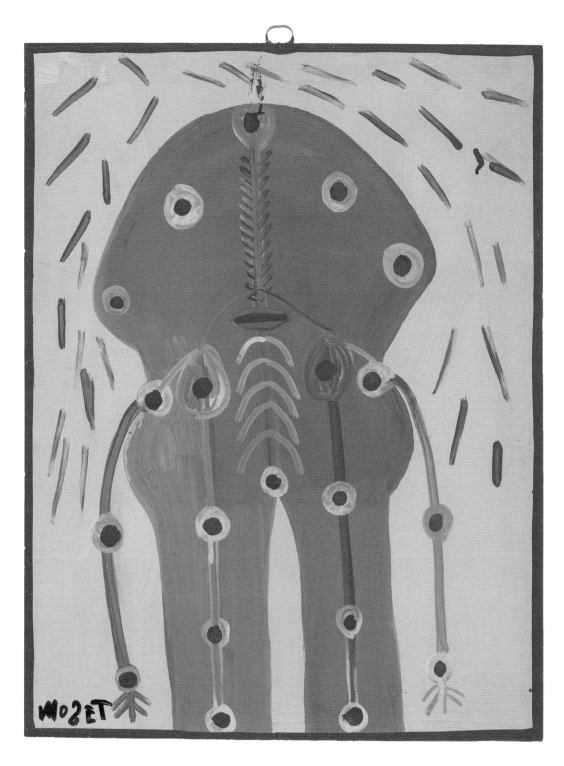

MOSE TOLLIVER
Dry Bones, About 1984

MELISSA VANDENBERG
Come Undone, 2012

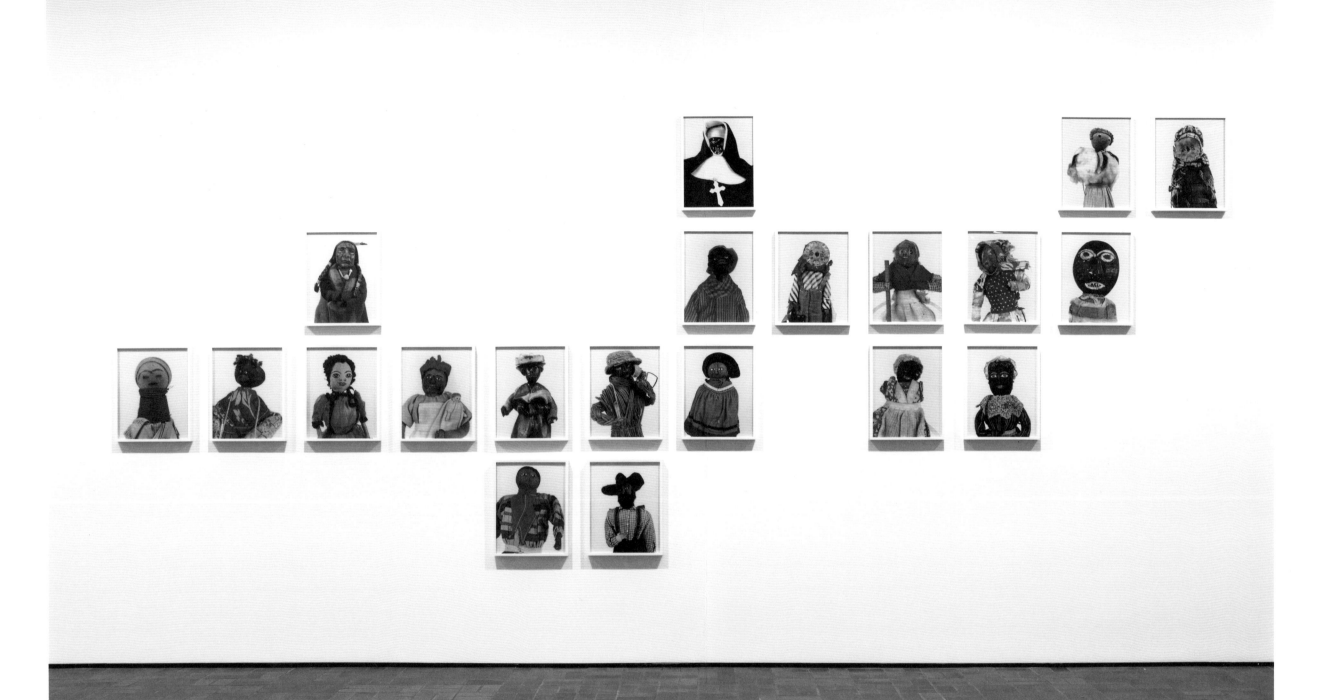

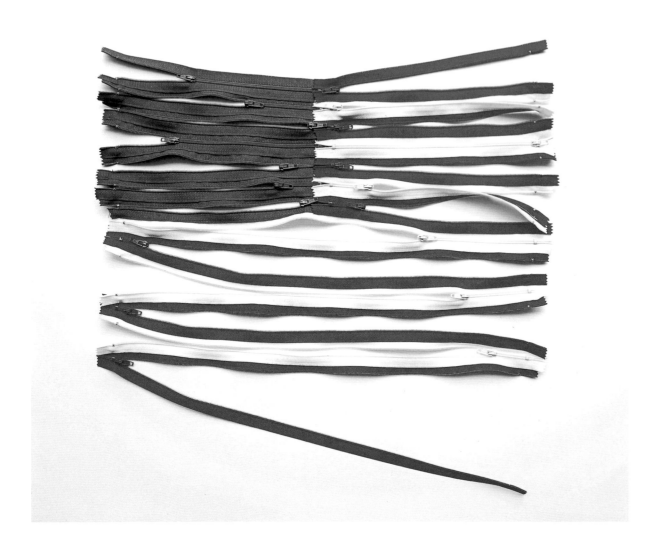

FRED WILSON
Old Salem: A Family of Strangers, 1995

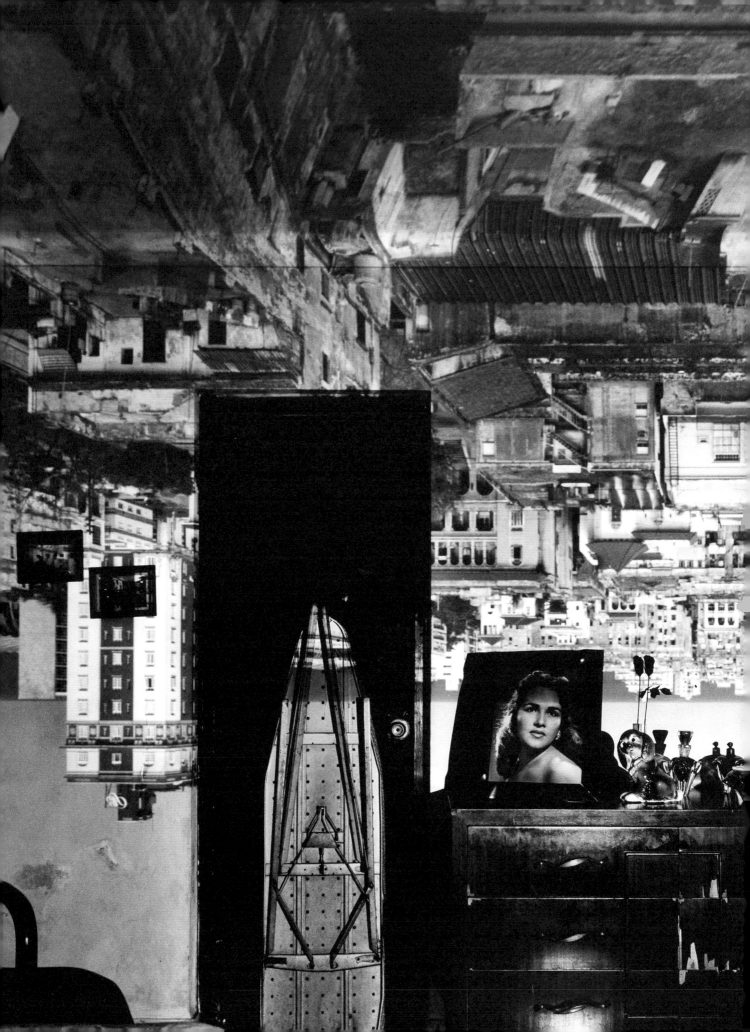

Ivy G. Wilson

/you_are _here_or_ remapping _the_ american_ south_as _the_glo bal_south

If the Global South marks the circumscription of a geographical zone where a politics of asymmetrical relationality suffuse, if not govern, that very space, there are innumerable Global Souths, both in the present moment and in the historical past. However, the particularity of our uneven distribution of resources and exponentialized inequality was accelerated by the world systems of colonialism and capitalism that instantiated late modernity. Inasmuch as the phrase "Global South" has precursors in terms like "Third World" and "developing countries," emanating from the contexts of the Cold War and liberal economics respectively, it is not difficult to ascertain why the United States has been reluctant to think of itself as having its *own* Global Souths.[1]

In the American popular imagination, the equator that ostensibly delineates the "North" from the "South" is the Mason-Dixon Line. In the American context, the iconography of the Mason-Dixon Line sometimes veils the similarities between the two halves of nation (as, for example, when Malcolm X famously quipped in 1964 that "There's no such thing as a Mason-Dixon line—it's America. There's no such thing as the South—it's America").[2] This veiling also applies to moments when the South has not been the economic subordinate of the North (as, for instance, when Southern plantations underwrote Northern industry in addition to producing three-quarters of the world's cotton supply in the years before the Civil War).

The American South is everywhere visible throughout the *Third Space* exhibition, conspicuously in photographs by Kevin Bubriski, Chris Jordan, and Gordon Parks and more latently in works such as William Eggleston's *Untitled* (1981–82), a scene of a porch swing. Eggleston, perhaps best known for *The Red Ceiling* (1973) and his technique of deep color saturation, was preoccupied with everyday life in the American South, especially as embodied in the quotidian objects of commonplace, average, and familiar experiences. His attention to this impulse is especially illuminated in *Untitled* (1982–83; p. 123), Eudora Welty's kitchen, in which his use of light and shadow and the curated feel of the table—as if the curtains are withdrawn to reveal a staged performance—evince what Erik Erikson calls the "ritualized customs of everyday life."[3] Welty's own deep interest in the South is no less evident in her photography than it is in her fiction, placing her not only in conversation with Eggleston but also with Walker Evans, Dorothea Lange, and Gordon Parks.

The eight Parks images included in the exhibition were among several dozen the photographer took for the Segregation Series as part of a 1956 *Life* magazine photo essay entitled "The Restraints: Open and Hidden." Parks took a different approach to documenting the Civil Rights movement in the series. Rather than shooting scenes of protests, sit-ins, and police violence in black and white, here he captured in color the everyday life of the Thornton family: washing clothes, cradling a young child, going to school, and attending church services, all in the segregated world of Alabama. Among Parks's images of black life under Jim Crow is *Mr. and Mrs. Albert Thornton, Mobile, Alabama, 1956* (p. 141), a photograph that illustrates the quiet rectitude and perseverance of the Civil Rights movement as a social cause that was equally public and personal, political and intimate. For the critic Maurice Berger, the framed picture adorning the Thornton's wall in Parks's photograph, spliced together as it were from two separate images, amounts to a "restitution of a lost history," with the wedding portrait serving "as both a commemoration of the couple's union and a poignant metaphor of the resilience and urgency of their bond against a tide spanning decades of intolerance and adversity."[4] With respect to temporality, the wedding picture not only reframes the age difference between the Thorntons but also—embedded in and contrasting with Parks's photograph—indexes a distribution of time and chronology over several generations of history.

While the idea of the Global South has pronounced geographical connotations, it might be considered principally a term that denotes

a relational condition that is perhaps most legible in political economy. Indeed, it is noted often that the quintessential feature of the Global South is its relationship to globalization, with pundits like David Harvey and Saskia Sassen critiquing globalization's neoliberal economic underpinnings and Anthony Giddens and Joseph Stiglitz advocating them.[5] The ways that globalization subtend the Global South can be illustrated by the example of Ireland, which in the nineteenth century embodied many of the attributes of a subaltern state relative to England and then removed from it owing to the economic boom of the Celtic Tiger at the very end of the twentieth century. This example also puts into high relief the centrality of borders and partitions with respect to how the Global South was initially intended to produce and police space in territories in close geographical proximity not only to the equator but also to different quadrants throughout the world.

One way to limn the meaning of the Global South in contemporary American art is by turning to Enrique Chagoya. A Mexican-born painter and printer, Chagoya's body of work, which often employs whimsy to level serious critique, addresses issues of religion, popular culture, the history of Mexico, and international politics through a wide range of media, including codices and drawing. The six lithographs that comprise *You Are Here* (p. 25), which were produced with the poet Alberto Ríos, play with the notion that the South is already embedded, figuratively if not constitutively, within the North. The dominant theme of the lithographs concerns maps and perspectival interpretation ranging from an aerial view of Earth from outer space (p. 25, lower left) and a retranslation of a classic Renaissance map of the globe with what appear to be the heads of two Día de Muertos figures (p. 25, lower right) to a reversed cylindrical map (p. 25, upper left). Taken together as a suite, the lithographs, concomitantly, seem to ask how one should view the processes of constructing and reconstructing home (p. 25, upper right) when attempting to apprehend those processes from the ocular perspectives, as well as the historical conditions, of being in a reversed, or so-called "south-up," orientation.

In literalizing a "south-up" orientation in the third lithograph from *You Are Here*, Chagoya both appropriates and vacates the pictorial map as a veritable emblem of popular Americana. His version is adorned with quaint scenes of pastoral homes and rolling hills that make up the green background of the image with an outlined map of the United States at the very center (p. 25, center right). However, unlike conventional pictorial maps that commonly depict monuments, historical events or persons, restaurants, and the like, Chagoya's

print illustrates the United States as an aqueous zone with an island in the middle. In this way, the print intimates that the Cold War practices that have reified the boundaries between Cuba and the United States have actually put the Global South in the very heartland of America.

Like Chagoya's lithographs, Abelardo Morell's *Camera Obscura Image of El Vedado, Habana, Looking Northwest, Cuba* (2002; p. 137) implores viewers to examine questions about the United States and the Global South within the hemisphere of the Americas. Part of Morell's Camera Obscura series, the image is composed of two different layers—the first image streams into a room that has been reconstructed to essentially function as the interior of a camera box superimposed onto the room itself, which is a staged or curated space—that he captured with a large-format camera. The personal history of Morell's own biography maps onto the social history of the Global South and the hemisphere of the Americas; long based in Boston, Morell and his family initially fled Cuba for New York City three years after the Cuban Revolution of 1959.

"Looking Northwest" Vedado should be considered for how Morell employs formal techniques as a means of foreshortening the space—physical, cultural, or otherwise—between a more distant nodal point over "there" and its closer, conceptual complement in proximity "here." That is, rather than reproducing an image from somewhere out "there" and rendering it as a reflection of itself upon a blank backdrop, Morell's Camera Obscura series depends on how the interplay between the "somewhere out there" contrasts with the closeness of "something here." And it is precisely this trope of "closeness"—figured both as geopolitical space and personal intimacy—that allows us to decode Morell's methodological practice for what it intimates about the Global South.

The meaning of Morell's piece is amplified by its title, *Camera Obscura Image of El Vedado, Habana, Looking Northwest, Cuba*, one that the artist underscores as being concerned with direction, orientation, and perception. The United States has long been preoccupied with Cuba. Well before the Spanish-American War of 1898, American military and commercial interests had sought a foothold in the longest Caribbean island some 90 miles from the southeasternmost tip of the continental United States. These efforts were further amplified during the Cold War and after. Morell compels the viewer to engage political questions precisely by telescoping them through ocular experimentations with sight and interpretation, perspective and representation.

While the Vedado, as the central business district of Havana, is a particular place or hyperlocation, the phrase "Looking Northwest" is less about place per se than it is a mandate about orientating and reorienting perspective, directing how the viewer not only apprehends Morell's photograph but also how the United States sees Cuba, and Cuba the United States. In a sense, then, Morell's *"Looking Northwest" Vedado* literalizes W. J. T. Mitchell's notion of "visual reciprocity" as a practice whereby "the everyday processes of looking at others and being looked at" unfolds and instantiates new forms and occasions of recognition insofar as the angular point of view "Looking Northwest" not only creates a perspective for looking into a particular district but also a way of looking at the United States. But the "looking at" the United States is complicated here by Morell having *not* used a prism to invert or render right side up America's geographical position above Cuba; in Morell's photograph, the United States is below Cuba and, in this sense, it shares an impulse with the first lithograph of Chagoya's *You Are Here*.[6]

Inasmuch as the title of Morell's work prefigures the Cold War politics of the United States and Cuba, the visual logic of the image, especially its use of light and shadows, seems to be moving in a different, more personal, direction altogether. There is a palpable distinction between the representation of the cityscape, with its austere buildings, and the domesticity, if not intimacy, of the staged room/camera box itself. Almost at the center of the photograph is an image that bears the likeness of the Brooklyn Bridge with its neo-classical pointed archway and modern suspension cables. But the image is actually a door draped to produce an archway, and the suspension cables are the skeletal underside of an ironing board. As the picture of either a contrived bridge or the actual door itself, this portal symbolizes new beginnings, moving from one state to another. The focal point of this staging, however, is the framed studio portrait of a woman resting upon a bureau next to numerous perfume bottles and a single rose. As one of Morell's few camera obscura images to feature human faces, the *"Looking Northwest" Vedado* piece is not an attempt to normalize U.S.-Cuban relations so much as an effort to humanize them through the figure of the female body whose corpus, within a remapped cartography where the Northwest is ostensibly the Southwest, floats between and connects the here and there, the inside and outside, and Cuba and the United States. In a critical maneuver, not dissimilar to how Parks reframes time and history in *Mr. and Mrs. Albert Thornton, Mobile, Alabama, 1956,* Morell reframes space and history.

If a number of works in the *Third Space* exhibition illustrate the vicissitudes of globalization, especially in the context of reinterpreting the American South (as part) of the Global South, the composition and construction of others in it, including Emma Amos's *Measuring, Measuring* (1995) and Hassan Hajjaj's *Brown Eyes* (2010), intimate that the production, if not reception, of art cannot be sufficiently apprehended when the world is divided into the halves of North and South or East and West, but rather it must be viewed globally.

notes

1 See Jennifer Greeson, *Our South: Geographic Fantasy and the Rise of National Literature* (Cambridge: Harvard University Press, 2010), and Sharon Montieth, "Southern Like US," *Global South* (Winter 2007): 66–74.

2 Malcolm X, "With Mrs. Fannie Lou Hamer," in *Malcolm × Speaks: Selected Speeches and Statements*, ed. George Breitman (New York: Merit Publishers, 1965), 108.

3 Erik Erikson, *Toys and Reasons: Stages in the Ritualization of Experience* (New York: Norton & Co., 1977), 78. As Maddy Foley notes, "Welty's emphasis on capturing Southern idioms and customs resonates with Eggleston's own Southern upbringing and adoration of commonplace scenes." Gund Gallery, Kenyon College.

4 Maurice Berger, "A Radically Prosaic Approach to Civil Rights Images," *New York Times,* July 16, 2012.

5 Alfred J. López, "The (Post) global South," *The Global South* (Winter 2007): 3–4.

6 W. J. T. Mitchell, "What Do Pictures *Really* Want?" *October* 77 (Summer 1996): 82.

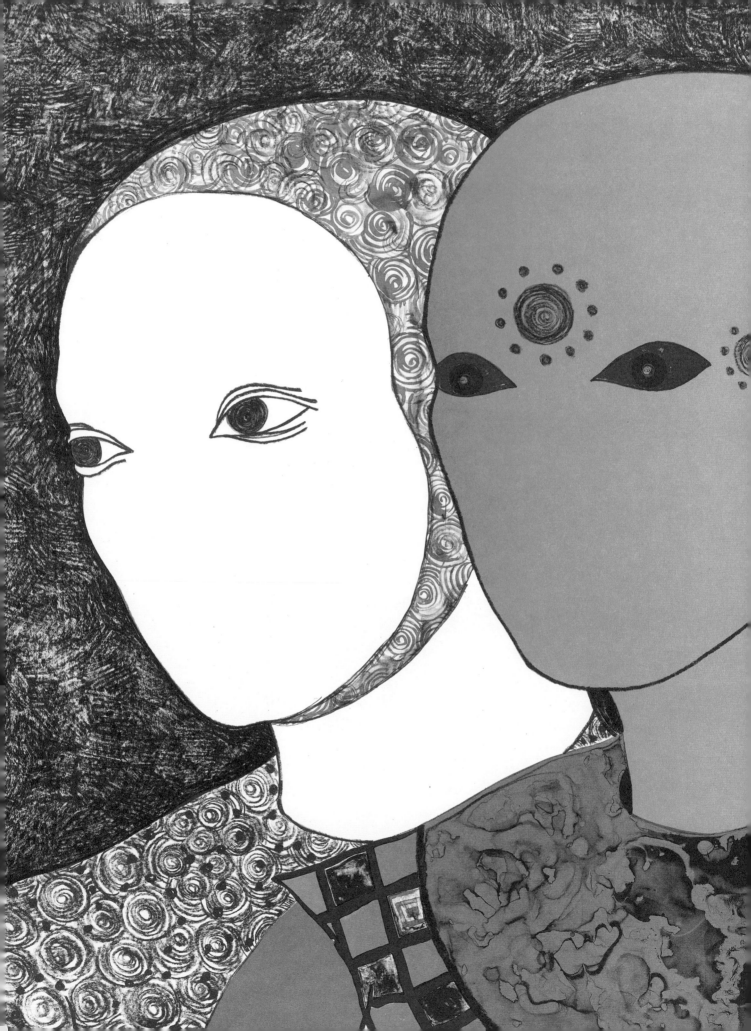

/representation_agency_gaze

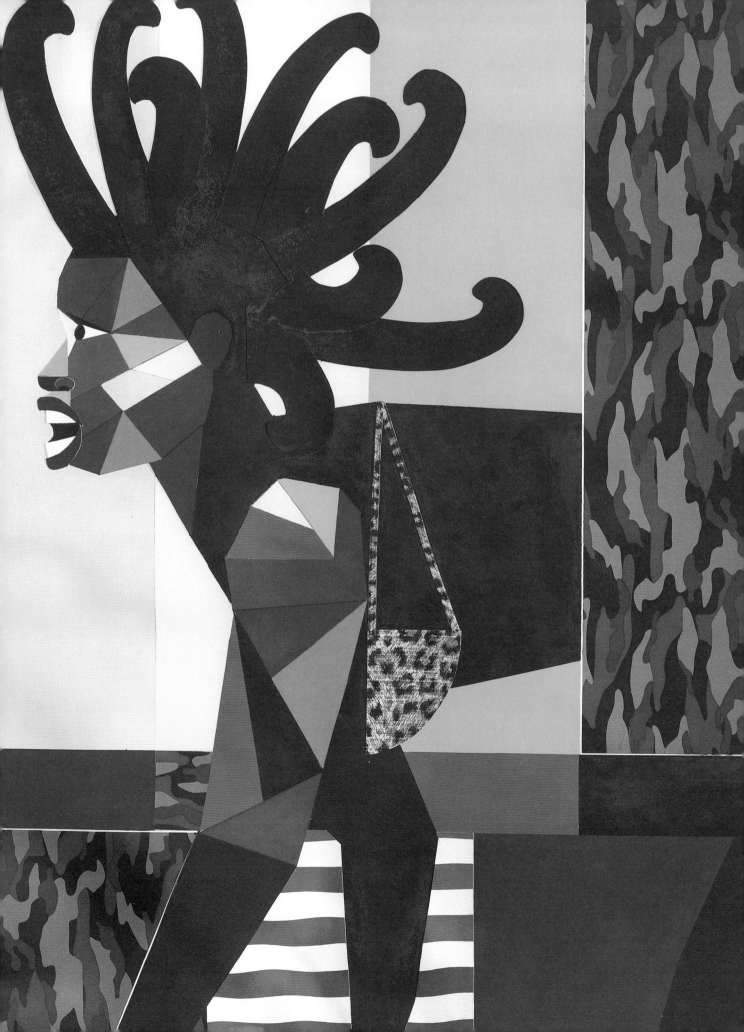

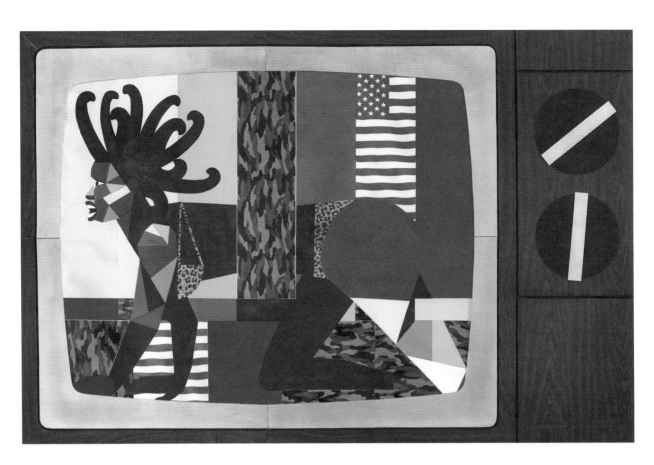

DERRICK ADAMS
I Come in Peace, 2014

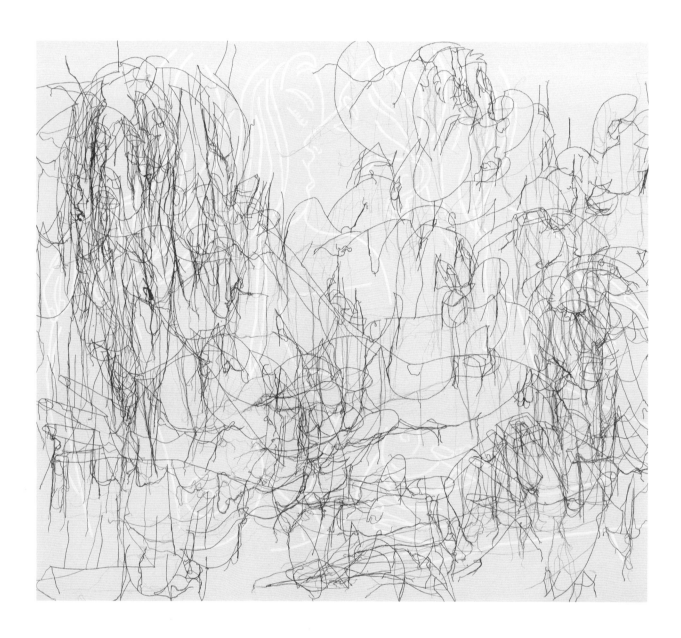

GHADA AMER
Les Nains, 2003

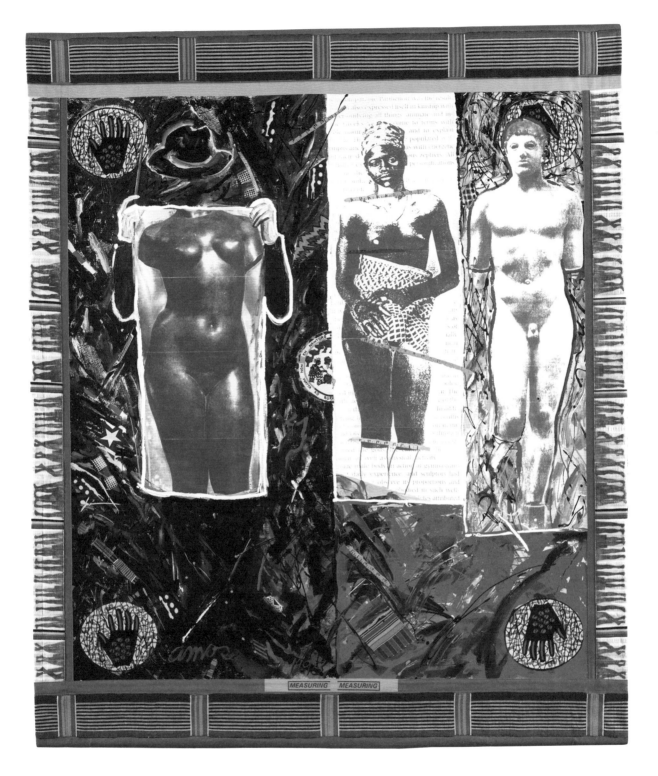

EMMA AMOS
Measuring, Measuring, 1995

21/40 [signature] /99

BELKIS AYÓN
Untitled, 1999

NICK CAVE
Soundsuit, 2009

60

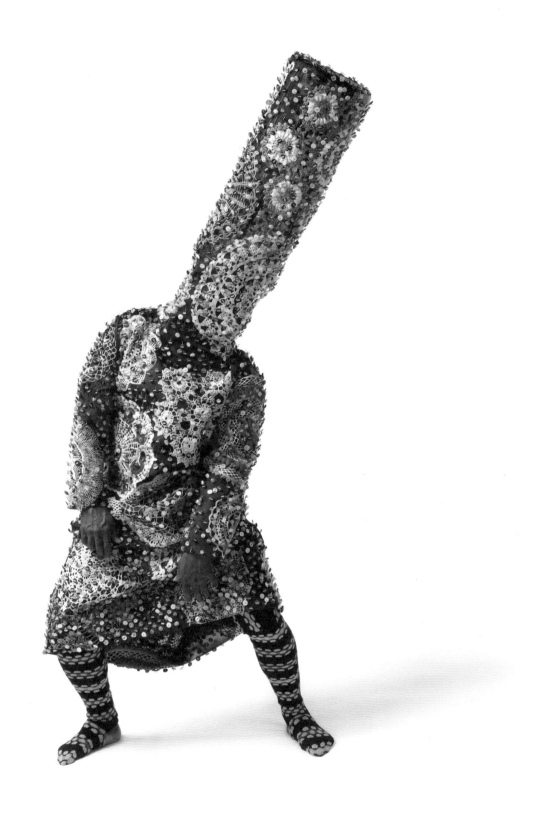

ZOË CHARLTON
Cousins 9, 2009

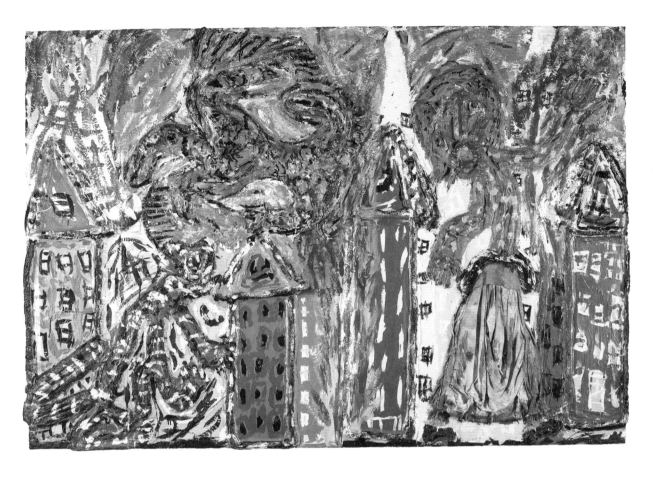

THORNTON DIAL
No Right in the Wrong, 1992

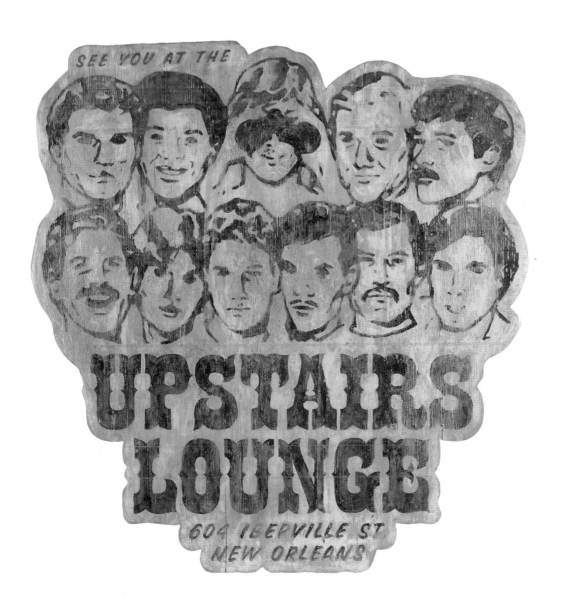

SKYLAR FEIN

See You at the UpStairs Lounge, from *Remember the UpStairs Lounge,* First edition 2008; this edition 2009

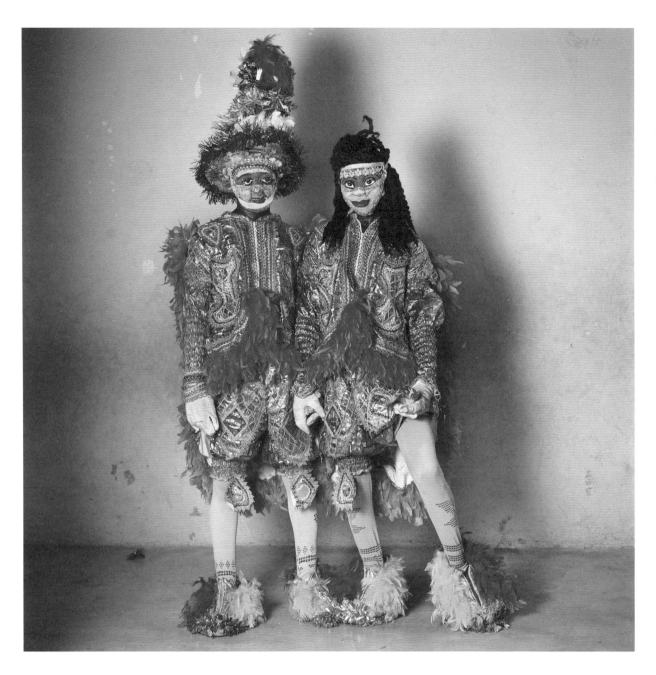

PHYLLIS GALEMBO
Fancy Dress and Rasta, Nobles Masquerade
Group, Winneba, Ghana, 2009

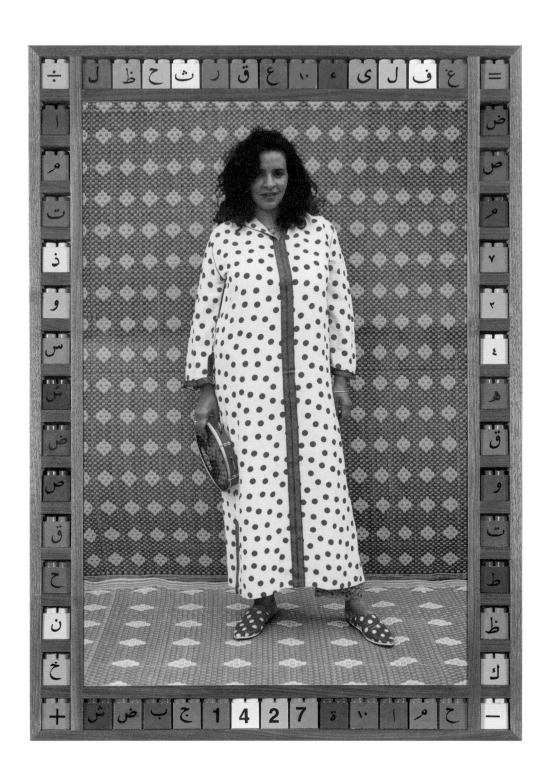

HASSAN HAJJAJ
Ya Amina, 2006

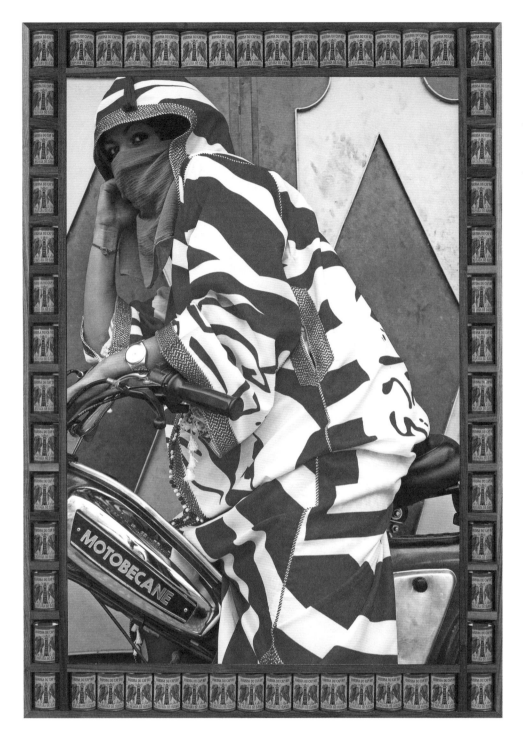

HASSAN HAJJAJ
Brown Eyes, 2010

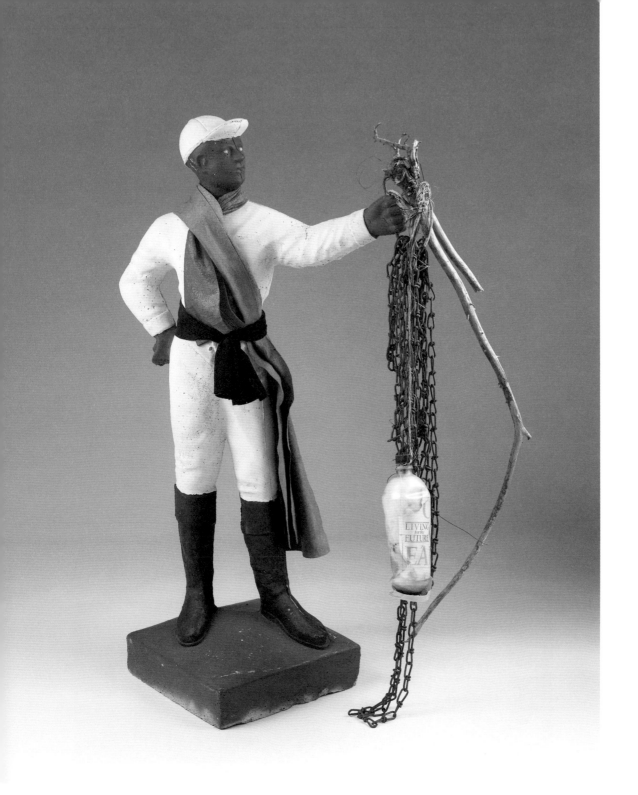

LONNIE HOLLEY

*The Pointer Pointing the Way
of Life on Earth*, 1997

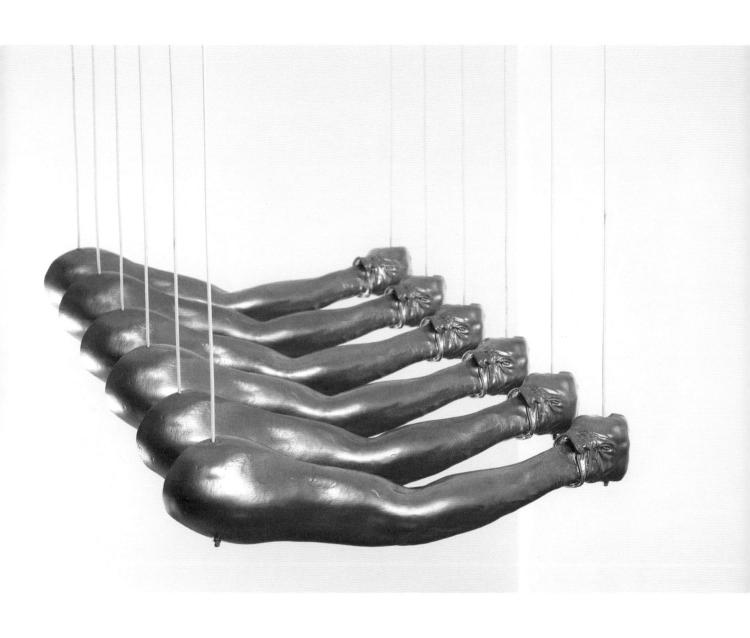

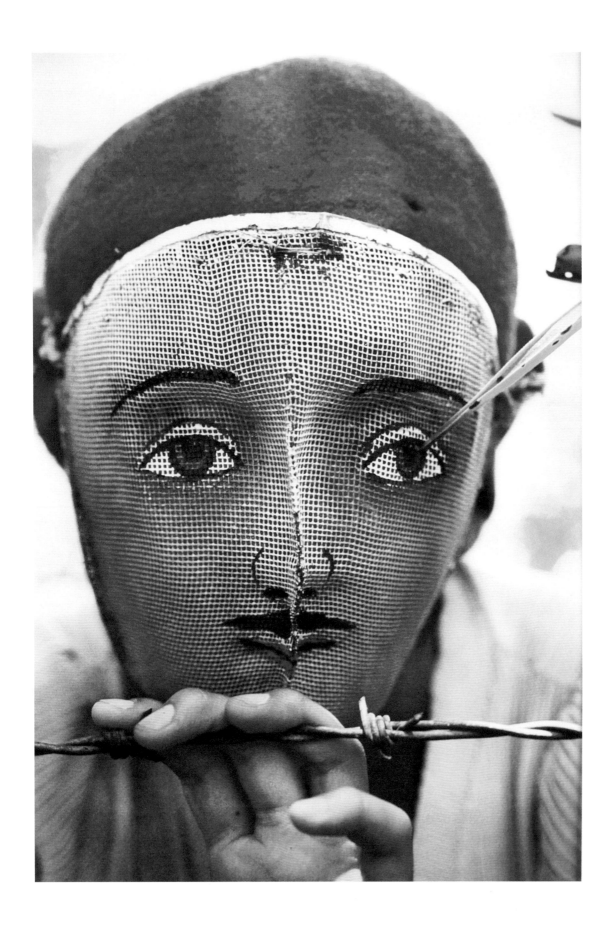

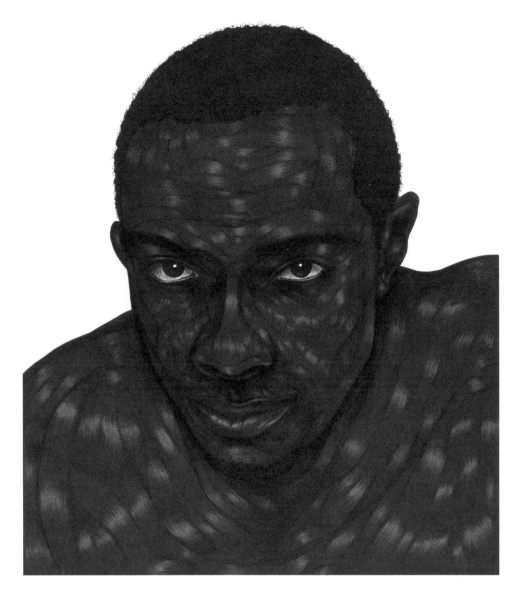

TOYIN OJIH ODUTOLA
Hank, 2012

SUSAN MEISELAS
Traditional Indian dance mask from the town of Monimbo, adopted by the rebels during the fight against Somoza to conceal identity (from "Nicaragua, June 1978–July 1979"), 1981

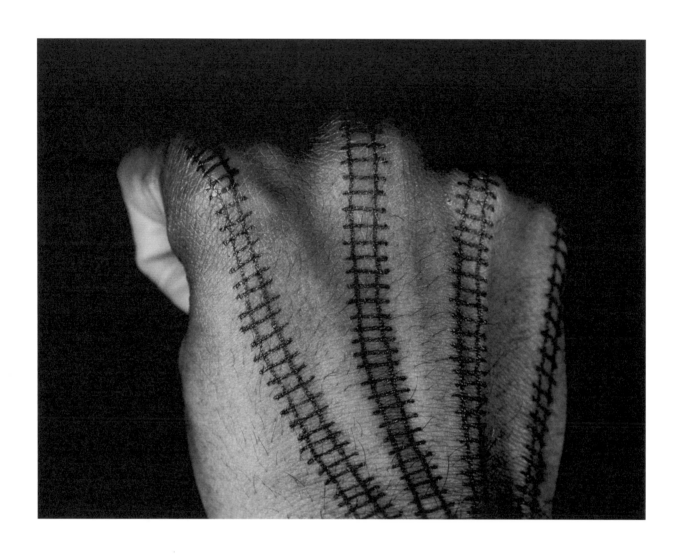

DEMETRIUS OLIVER
Tracks, 2003–05

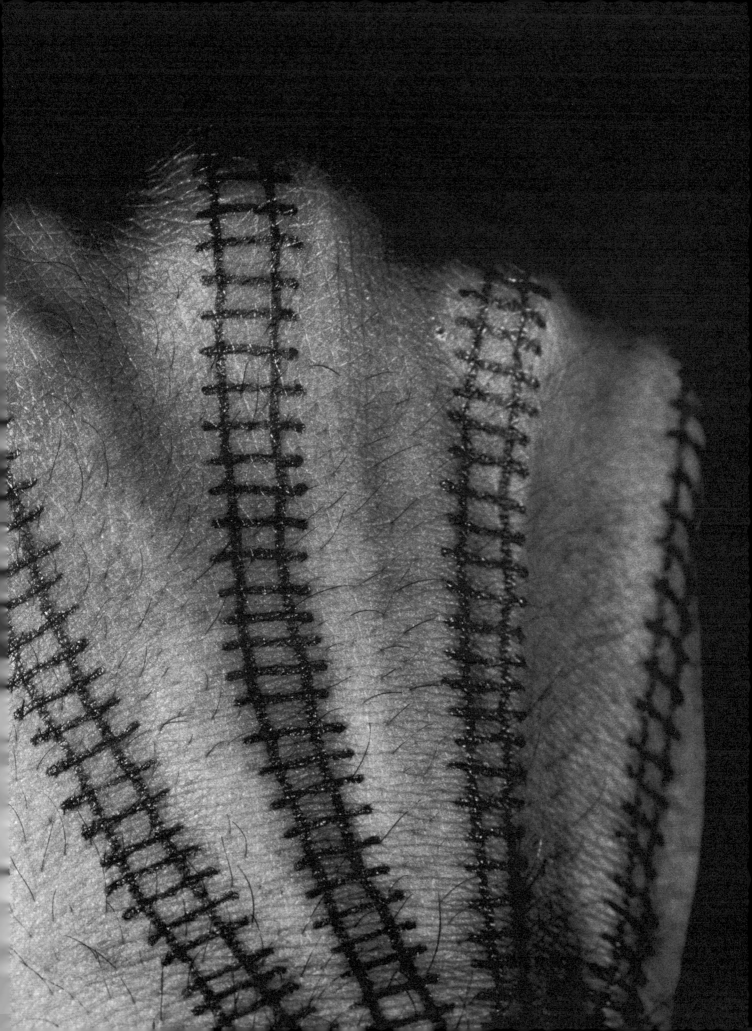

DEMETRIUS OLIVER
Seminole, 2004

DEMETRIUS OLIVER
Hearth, 2006

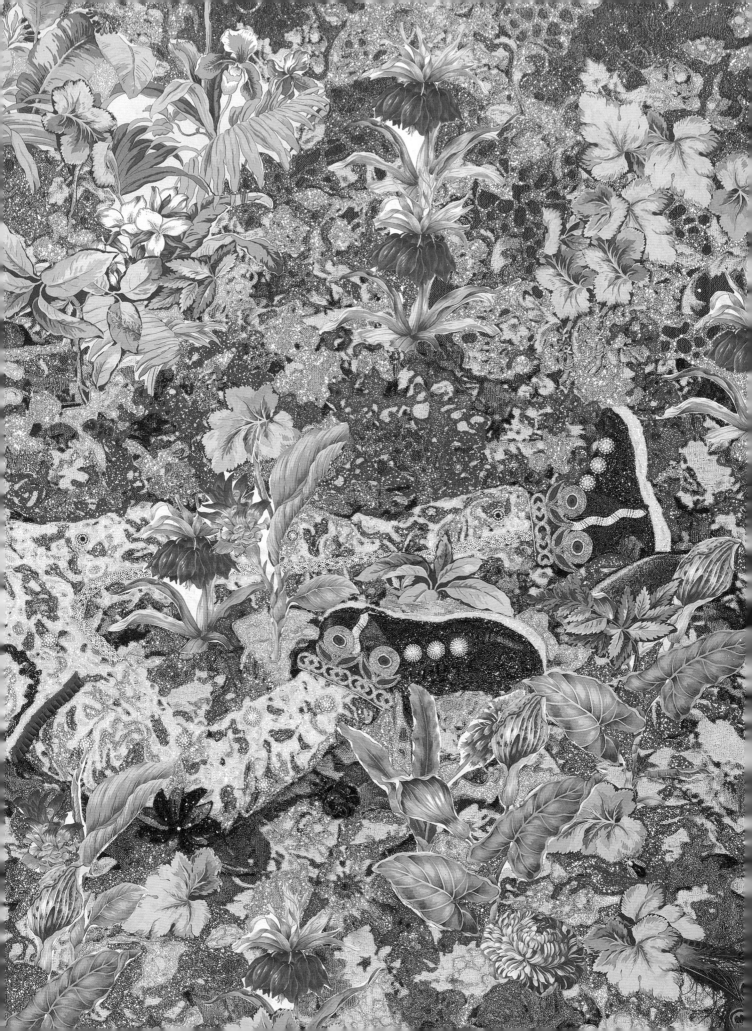

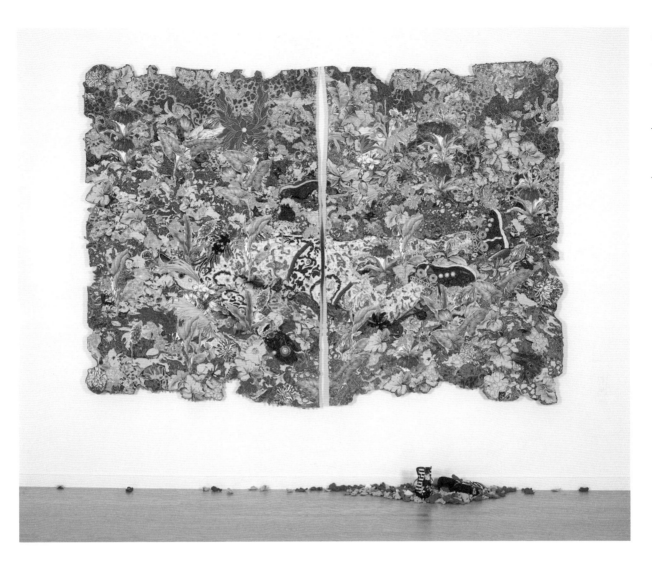

EBONY G. PATTERSON
among the weeds, plants, and peacock feathers, 2014

JEFFERSON PINDER
Sean (Mercy Seat) from the Juke Series, 2006

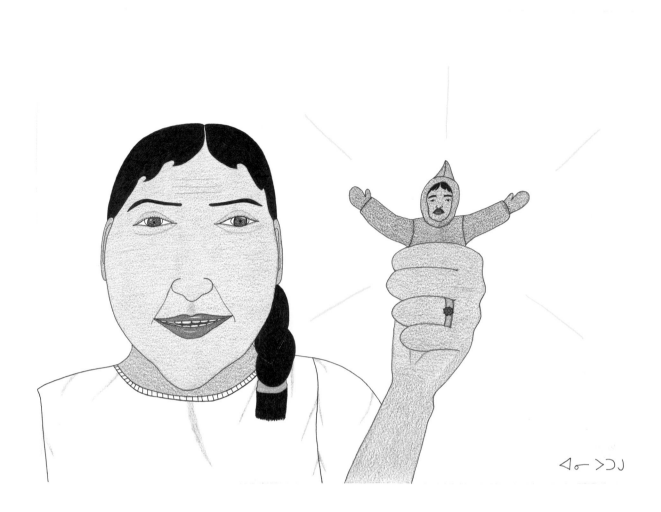

ANNIE POOTOOGOOK
Untitled, 2006

LIBERATE OUR MINDS

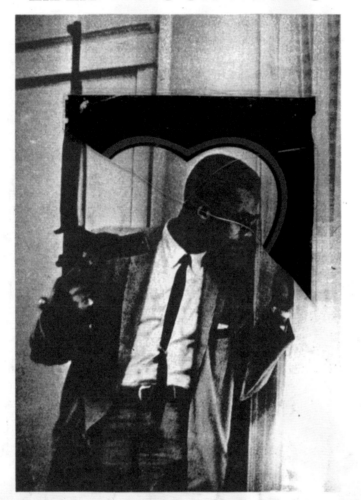

BY ANY MEANS NECESSARY

MARC ROBINSON
Untitled (Malcolm X and Heart Fragment), 2008

CINDY SHERMAN
Untitled #213, 1989

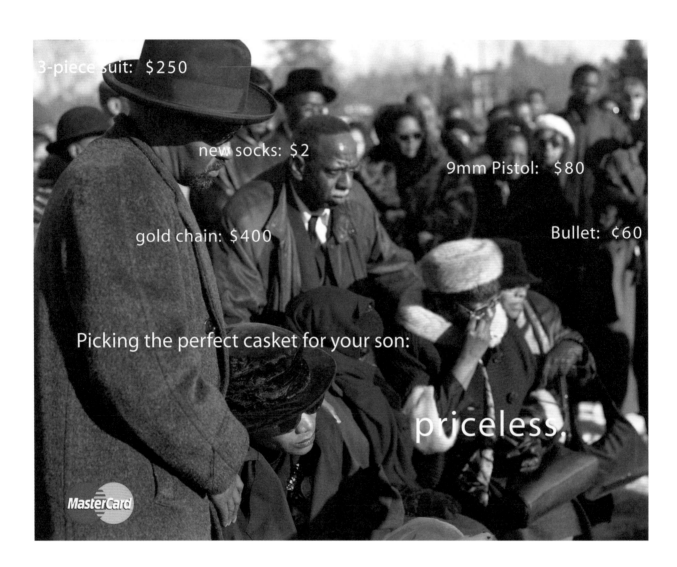

HANK WILLIS THOMAS
Priceless, 2005

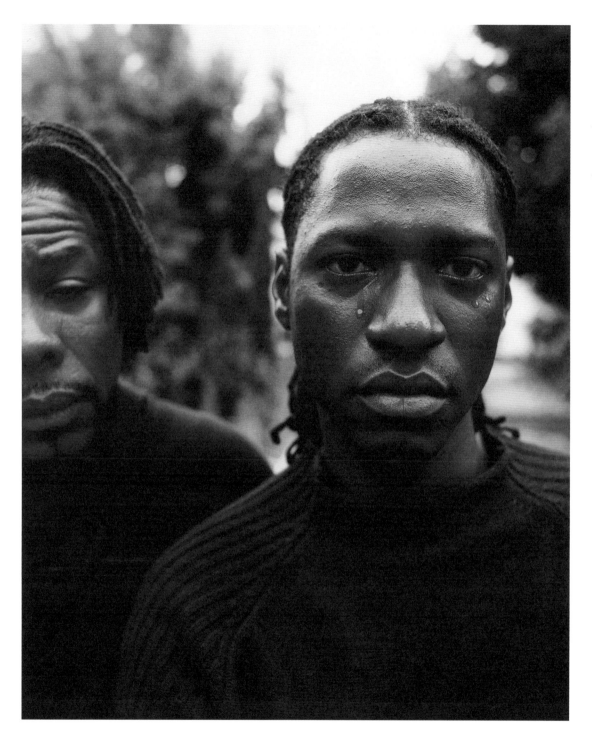

HANK WILLIS THOMAS
Jermaine and Logan, 2002; printed 2006

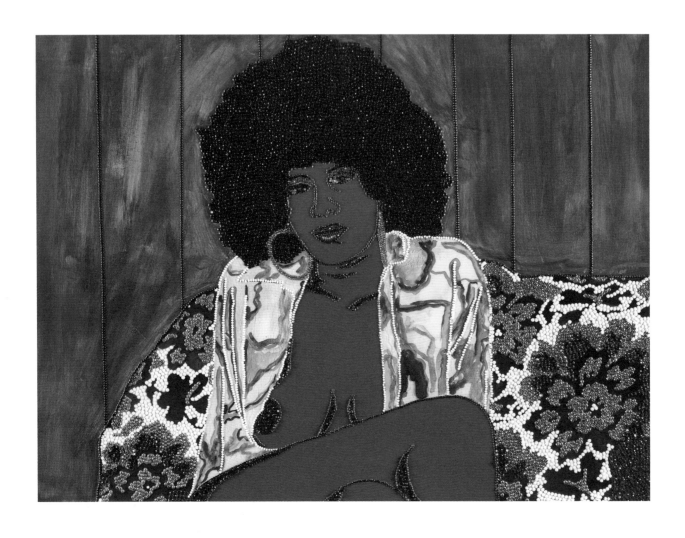

MICKALENE THOMAS
*Do What Makes You Satisfied (from the She
Works Hard for the Money series)*, 2006

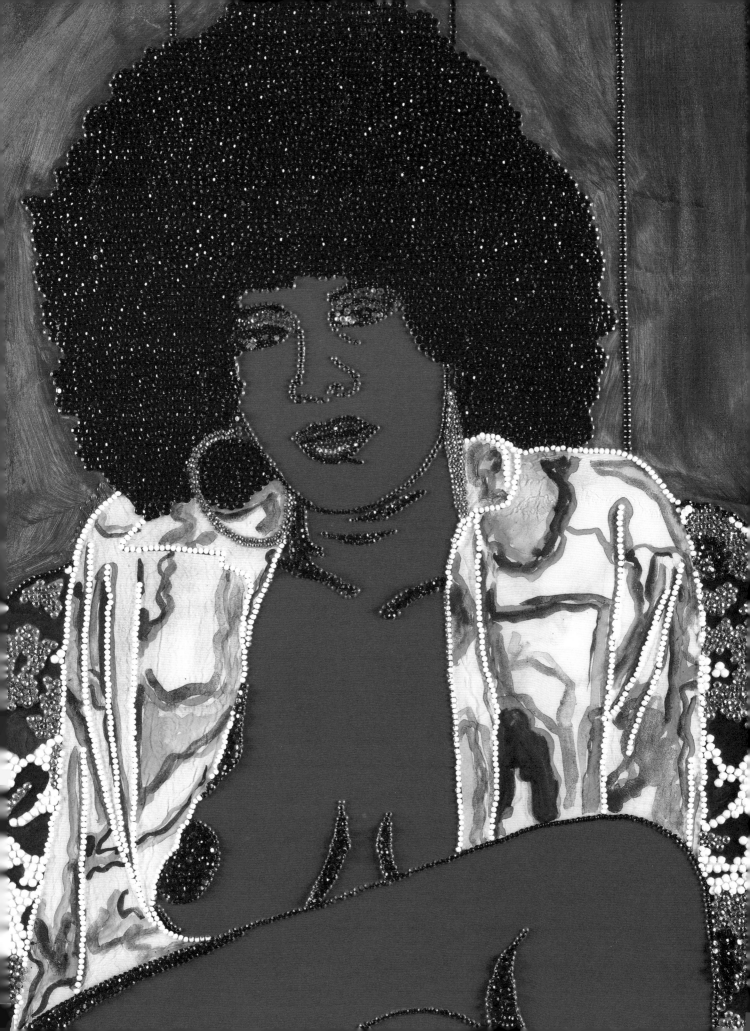

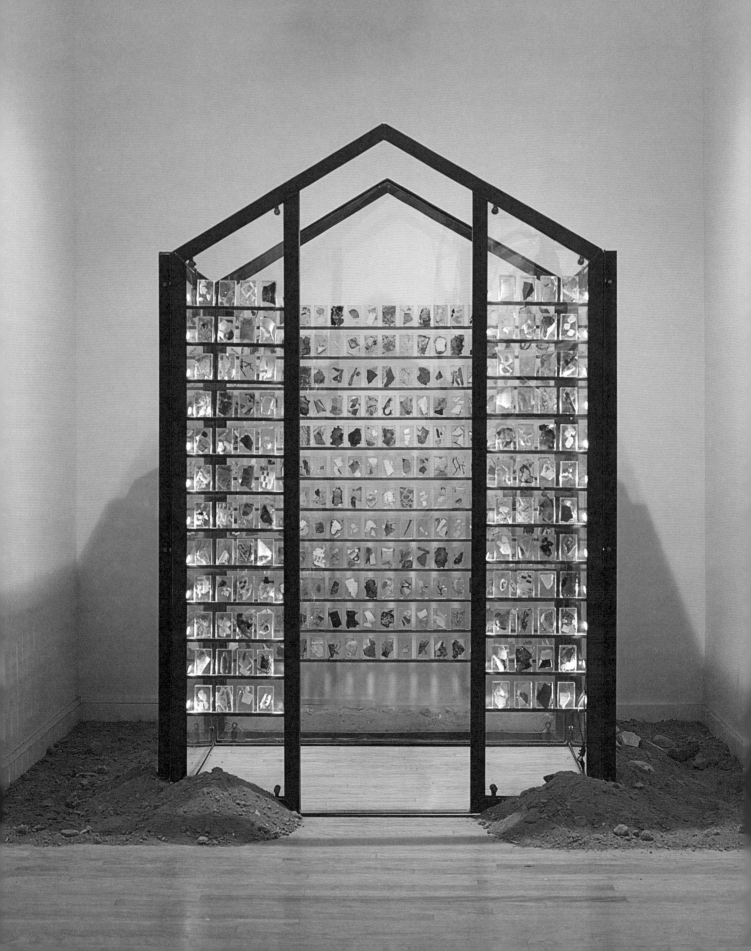

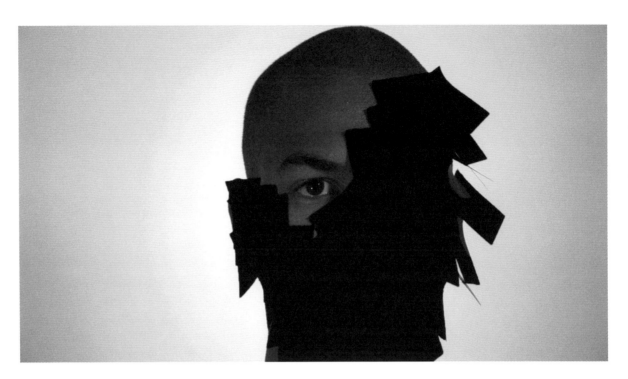

WILMER WILSON IV
Black Mask, 2012

SUE WILLIAMSON
Mementoes of District Six, 1993

by H. G. Masters

/a_cent ury_of _lost_ symbols

In Glenn Kaino's installation *Bridge* (2014), two hundred gold-painted arms are suspended from the ceiling in an undulating row, like a slatted rope bridge or the spine of a dinosaur in a natural-history museum.[1] On closer inspection, those identical arms are wearing gloves on their clenched fists. They are casts of the right arm of Tommie Smith, who at the 1968 Summer Olympics in Mexico City raised his arm above his bowed head during "The Star-Spangled Banner" after he won the gold medal in the 200 meters.[2] The images of Smith standing on the podium next to his teammate John Carlos, who had won the bronze, with their black-gloved fists raised, was a gesture meant to resonate around the globe. As Carlos told *Life* magazine the next day, "We wanted all the black people in the world—the little grocer, the man with the shoe repair store—to know that when that medal hangs on my chest or Tommie's, it hangs on his also."[3]

The clenched fist as a symbol of defiance has its modern origins in the 1848 communist revolts in France, nineteenth-century left-wing labor movements, the International Workers of the World at the Internationale in 1917, and anti-fascist (Republican) forces in the Spanish Civil War of the mid-1930s. It is in stark contrast to the open, extended fist of the infamous Nazi salute. In the United States, the symbol was used by the Student Nonviolent Coordinating Committee (SNCC), from a drawing by Frank Cieciorka, and later by the antiwar group Students for a Democratic Society and the Black Panther Party. The gesture became an international cultural meme after Smith and Carlos broadcast it on the world's biggest stage, and it has returned in logos for solidarity movements around the world (though it is usually the "left" fist that represents socialist causes).[4] Today it is resurrected in the protests of Black Lives Matter. The

raised fist has ridden the cultural waves over the decades, across continents and through cultures, as the form of Kaino's installation suggests. Just as in Kaino's sculpture, the gesture itself forms the components of a bridge between diverse resistance and solidarity movements.

Bridge, a segment of which is included in Third Space, reminds us of how, as the twentieth century recedes in our collective memories, "the modern" was a search for things universal—whether moral, economic, or aesthetic. Humanism, communism, and socialism were all ideologies that were meant to be transnational, uniting people in beliefs irrespective of nationality. Those aspirations were frequently enmeshed in struggles that were very specific to certain places, such as the Civil Rights movement in the United States or anticolonial, liberation struggles in Africa and Southeast Asia. How and why Smith and Carlos raised their fists at the 1968 Olympics had as much to do with the poverty of segregation-era Alabama circa 1956, as captured in the photographs of Gordon Parks, as with the assassination of Martin Luther King Jr. on April 4, 1968. But the athletes' gesture was also connected to the International Olympic Committee's decision to reinstate apartheid-era South Africa into the Games (a decision that was later overturned). As Carlos's remark to Life magazine indicated, the idea of black power was related to the condition of African Americans as well as to global freedom movements, liberation politics, and anticolonialist struggles.[5]

Since the tumult of the late 1960s, the progress of self-determination movements has tracked closely with the larger international process of (and discourse about) decolonization. Both are ongoing, incomplete projects, stymied as much by economic changes as political ones. In the mid-twentieth century, the socialist component of most anticolonial, self-determination movements was a central one. Thinkers like Martinique-born psychiatrist and philosopher Frantz Fanon saw race and wealth as ineluctably bound: "You are rich because you are white, you are white because you are rich."[6] Third World socialism—the idea of a non-Soviet, centralized economy for countries newly emerging from colonial rule—was embraced by figures from Fidel Castro in Cuba to Julius Nyerere in Tanzania, and from Jawaharlal Nehru in India to Sukarno in Indonesia, as well as many Arab leaders, including Egypt's Gamal Abdel Nasser. The goal of these leaders was rapid development that would bring their countries up to the levels of the capitalist (so-called "First World") and communist ("Second World") states. Tragically, in many cases this aspiration of economic and national independence was thwarted by the proxy struggles of the Cold War, where the

H. G. MASTERS

pursuits of economic and social justice often clashed, creating irreconcilable contradictions.

Mel Chin's large multimedia sculpture *The Sigh of the True Cross* (1988) represents part of that story. The artwork's form is meant to recall the Ethiopian single-string lute *masenqo*, or "spike fiddle." Yet what many of us see first are the hammer and sickle with a cross grafted onto it, representing, in Chin's description, the two opposing forces (the USSR, which backed the Workers' Party of Ethiopia, and international charities, respectively) that caused the devastating famines in the mid-1980s. The shape of the country's borders is etched into the outline of the sickle. This mash-up of symbols betrays no love for any of them—quite the opposite. Their accumulation is ironic, and Chin deploys them cynically, to juxtapose their promise with their failings. In this sense, Chin's sculpture exemplifies a postmodernist approach: deconstructing the meaning of the "great" symbols of the modern era to reveal or criticize the horrors these ideologies had done in the name of progress. It also implicitly suggests the ways decolonialism was never fully achieved. European influence (in ideas and material) was no longer an occupying colonial power but had transformed into a Soviet-backed military insurgency (the Derg) that overthrew Haile Selassie's government while international aid agencies collaborated with the regime to forcibly resettle millions of people.

Symbols get co-opted, they die as clichés from overuse, and they are undermined by their misuse. Today the raised fist is an emoji on your smartphone. It has been adopted by white supremacist and mass-murderer Anders Behring Breivik. Many people noted that even Donald Trump raised his fist during the presidential inauguration in January. Yet the very next day, Deva Pardue's design of three different skin-toned, nail-polish-wearing clenched fists circulated widely at the Women's Marches held across the United States and abroad. Who is to say that symbols cannot be resurrected?[7]

When decoupled from specific ideologies, symbols are potent vessels for multiple meanings, and many artists have developed their own personal iconographies based on transforming symbols. Looking at Willie Cole's magnificent, massive woodblock print *Stowage* (1997), for instance, we see a pentagonal form filled with rows of dots surrounded by twelve circles bearing what look like heraldic symbols. Knowing the title, the symbols transform. The central form recalls diagrams of slave ships, each point standing for a person whose body was packed into the hull. The heralds resemble something else entirely—the pattern of vents on the underside of an iron, recalling the forms of domestic work for which so many African

slaves were destined. Willie Cole has an interesting diagram on his website about the "source and meaning" of the irons in his work.[8] A flowchart of sorts, it includes an image of a domestic iron at the center. Arrows lead out from there in a chain of associations, to images of white and black women, a boat, fire, water, the chemical element iron (FE), and eventually a slave ship, a map of the African continent, a bas-relief and sculpture, and at the bottom right corner, a bag of money. The iron is a motif in Cole's practice, recurring for its many resonances with slavery and domestic work, and in particular, slaves who were branded by their owners. Cole even uses the iron to imprint bodily forms in his series Hot Bodies (2013).

Cole's Stowage recalls a series of conversations I listened to during a two-day multidisciplinary symposium in Dakar, Senegal, called "Vive L'Indépendence de l'Eau" ("Long Live the Independence of Water") and organized by the Algerian-born artist Kader Attia as part of a yearlong series of events happening in different cities, part of Sharjah Biennial 13.[9] The speakers ranged from poets to filmmakers, professors of various environmental and social sciences, and architectural historians—all of whose research, in some way, had led them to the subject of water. One of the speakers, Professor Ibrahima Wane, the director of the African Studies graduate program at Cheikh Anta Diop University, spoke about the centrality of water to all aspects of Senegalese life and culture—from the coastal fisherman to the inland farmers.[10] Toward the end of his talk, Wane also noted the "ambivalence of water: as a source of life but also of tragedy, like the slave trade." Dakar, which occupies a hook-like peninsula, is the furthest western point on the African continent and was a pivotal harbor in the Atlantic slave trade. The boat, as a symbol in Senegalese culture, moves between being the source of life (food and livelihood) and the cause of death and devastation.

In the early twenty-first century, in both literal and metaphoric ways, the great symbols of the modern era lie scattered around the earth, many broken or stripped of their original meanings. From an artist who was born in the still nominally communist People's Republic of China, we get a distinctively contemporary perspective on the relationship between ideologies and symbols in Sun Xun's animated video People's Republic of Zoo (2009). The artist recreates the characters of George Orwell's allegorical novella of Stalinism, Animal Farm (1945), in the style of Chinese ink painting, mixing the animals of the Chinese zodiac with scenes of socialist order—Communist worker's statues in a banner field with a lone memento-mori-style skull, a Stalinist-style pavilion—and "imperialist" symbolism such as a pig in a suit watching a globe spinning around and a

mushroom cloud. The deployment of symbols here is nonideological, in the sense that the artist is not promoting one or the other, but nonetheless critical, grafting a universe of Chinese cosmology onto a parable about the evils of Stalinism—an ideology of one-person authoritarianism—with obvious implications for the present.

Symbols worked for modernist ideologies were meant to be applicable to all peoples everywhere precisely because they defied linguistic borders. The modernist project (and "modernization" at large) was one that created an international system of values, law, and ethics, and for the economy—the latter being where perhaps modernism has left its largest impact. Yet we still have everywhere within this globalized system what economists call "dual economies," where two systems exist in parallel: one based in manufacturing and sophisticated technology that is geared toward an international market, and the other that uses basic tools and agrarian labor and meets sustenance-level needs.[11] As postcolonial theorist Homi Bhabha points out: "Dual economies create divided worlds in which uneven and unequal conditions of development can often mask the ubiquitous, underlying factors of persistent poverty and malnutrition, caste and racial injustice, the hidden injuries of class, the exploitation of women's labor, and the victimization of minorities and refugees."[12] The walls, or "barriers to entry" (again, invisible and real), erected between these two worlds are becoming higher and more numerous. The colonialization of today is a neoliberal, technocratic one, where multinational corporations administer countries' natural resources back to the populations from whose lands they were extracted, and the relative wealth of an individual defines their access to legal protections. Perhaps the figures in *Third Space* who best represent that transnational class are the ones in Tomoo Gokita's coolly ironic painting *Be Just Like Family* (2015): men in tuxedos and women in ball-gowns, all with their faces obscured to appear perfectly generic yet obviously from the upper echelons.

To echo some of the things that were discussed at the Sharjah Biennial symposium in Dakar, many artists and academics there spoke of the need to decolonize the Senegalese (and broader African) society from the international corporations that supply concrete, steel, and other materials of "development" that are not environmentally sustainable; have a planned obsolescence contained in them; and destroy forms of local knowledge, craft, and belief. In every corner of the world, the environmental destruction, loss of indigenous or folk traditions, and social inequality can be traced as consequences of the global economic system. This is captured in Merritt Johnson's painting *Crow booming the One Big Water,*

Gulls flying away (2010), for instance, with its immediately understood reference (despite its abstraction) to the explosion of British Petroleum's Deepwater Horizon oil rig and the disastrous consequences for the ecosystem of the Gulf of Mexico.

The new decolonialization, then, looks very different than the internationalist, leftist rallying cries of the twentieth century. Rather than having one symbol for many people—the modernist way—the struggles for self-determination need another approach, one with a kind of solidarity that underlies differences. One place where this struggle of self-determination plays out in a heightened manner is in Israel-Palestine, and the issue has been central to Palestinian society since at least the late nineteenth century.[13] In the first week of October 2016, I was in the Old City of Jerusalem for a biennial exhibition called the Jerusalem Show, which situates artworks within the many interesting buildings and institutions in the historic city. The curator of the exhibition, Vivian Ziherl, made the following proposal: "an art of connections is [the] deepest need of our times."[14] Ziherl defined these connections as being perhaps "strange, charismatic, even oblique" but nevertheless able to overcome a "map of political struggles [that] appears evermore as an archipelago," and the "division, confinement, isolation" of minority communities in countries around the world.

Ziherl was specifically interested in what she identified as places of "settler colonialism"—where the colonizing population comes to stay, such as Australia, New Zealand, South Africa, the United States, and Canada, as well as the immediate context of Israel/Palestine— and her exhibition brought together artists whose cultures are not related through geographic proximity (either by nation or region), or by a kind of visual or methodological commonality. Instead, at the very real risk of creating false equivalences between very different situations, Ziherl showed artworks made by several artists from the Druze community of Majdal Shams (located in the occupied Golan Heights), from different indigenous Australian communities, an artist from the Shan ethnic minority in Myanmar (Burma), a series of projects by a collective from post-apartheid South Africa, about the Surinamese immigrant community in Amsterdam, and, of course, Palestinian artists. What the artists shared was an attitude of response or resistance to their conditions of separation, neglect, and oppression, where histories are not told, voices are not heard, and struggles are ignored within societies that share structural and historic similarities.

This approach can be universally applied and remain locally relevant—and vice versa. The specificities of local histories and

struggles should be seen as universally relevant, as they repeat in different forms in far-flung diasporas. El Franco Lee II's painting *Nightmare Katrina 2* (2006), showing a boat of armed police officers and stranded local residents, depicts tragic events in Louisiana in 2005, which were the consequence of climate change and deliberately negligent governance. Lee's self-described form of "urban manner pop art" is equally apt for the photographs of Hassan Hajjaj, a Moroccan-born, London-based artist whose studio-style photographs capture figures in flamboyant costumes and settings articulating a global hybridity, with traditional motifs from North African design and fashion reinterpreted through objects of global consumerism. A more documentary approach to the same phenomena can be seen in Phyllis Galembo's photograph *Fancy Dress and Rasta, Nobles Masquerade Group, Winneba, Ghana* (2009) from her long-running series Maské, which captures two decades of travel around western and central Africa and Haiti, and documents masquerade events and carnivals to present a widely dispersed and syncretic form of a cultural diaspora. Sculptor and modern dancer Nick Cave's *Soundsuit* (2009) is a single artist's personal continuation of that legacy, made to his body size and in his own wildly free aesthetic that draws on diverse African and African American styles.

In looking at an exhibition like *Third Space*, practicing the "art of connections" is a choice to seek out affinities rather than similarities between artists who do not (or did not) necessarily have real or even geographical connections. In that vein, the surrealism of Annie Pootoogook's untitled 2006 drawing, of herself holding up a miniature radiating Inuit figurine—like a displaced, and partially ironic, token of her native identity—can be seen alongside Tabaimo's lithographs, in which the repressed animal spirits (fish, tortoise, and rooster) of traditional Japan disrupt a modern existence and body parts (hands and a brain) appear gruesomely severed. David Driskell's *Ghetto Wall #1* (1971) features a black head, whose features are only half articulated, above what looks like a mural-, graffiti-, and poster-covered side of a building. Many of Mark Bradford's massive canvases are made from layers of the "merchant posters" that he finds around Los Angeles and layers, lacquers, and sands down to a form that can resemble sprawling urban topographies seen from above. Returning to Nick Cave, his very first *Soundsuit* was made in response to the beating of Rodney King by Los Angeles police officers in March 1991 after a traffic stop. Cave said he gathered up sticks from the ground, cut them into three-inch pieces, and sewed them into an outfit that made sound when he walked in the costume.[15] Thornton Dial's painting *No Right in the Wrong* (1992)

depicts the 1992 riots that followed the acquittal of the four police officers who brutally beat King. Melvin Edwards made versions of his welded metal sculptures in the Lynch Fragments series beginning in 1964, yet *Premonition* (1990) eerily prefigures King's beating the following year with its baton- and fist-like forms—the fist returning abstractly, obliquely in Edwards's sculpture to play a violent and oppressing function, rather than the emancipatory one suggested in Glenn Kaino's installation *Bridge*.

notes

1 Glenn Kaino's *Bridge (Section 1)* (2014), on view in *Third Space*, is a portion of the original installation shown in Washington, DC, in the exhibition *Alter/Abolish/Address* as part of the citywide public art program 5×5:2014.

2 The gesture (combined with the black leather glove) was immediately interpreted as a Black Power salute, including by the International Olympic Committee, though Smith wrote in his 2009 memoir *Silent Gesture* that it was a "human-rights salute." Tommie Smith, *Silent Gesture: The Autobiography of Tommie Smith* (Philadelphia: Temple University Press, 2007), 22.

3 John Carlos, in Jeremy Larner and David Wolf, "Amid Gold Medals, Raised Black Fists," *Life Magazine*, November 1, 1968, 64C.

4 J. David Goodman, "The Raised Fist Salute Has Varied Meanings," *New York Times,* April 16, 2012, https://thelede.blogs .nytimes.com/2012/04/16/ raised-fist-salute-has-varied -meanings/.

5 As just one well-known example: Stokely Carmichael moved to Guinea in 1969, changed his name to Kwame Ture, and became a vocal socialist and pan-Africanist.

6 Frantz Fanon, *The Wretched of the Earth*, trans. Richard Philcox (New York: Grove Press, 2004), 5.

7 Niela Orr, "What Does the Raised Fist Mean in 2017," Buzzfeed News, February 1, 2017, https://www.buzzfeed .com/nielaorr/what-does -the-raised-fist-mean-in-2017.

8 See Willie Cole's website, http://www.williecole.com /irons.html.

9 See H. G. Masters, "Sharjah Biennial 13: Dakar, 'Vive l'Indépendence de l'Eau,'" *ArtAsiaPacific*, http://artasiapacific.com/Blog /SharjahBiennial13Dakar.

10 Wane also noted that it is commonly believed (though disputed by academics) that the name Senegal comes from

the Wolof phrase *sunu gaal,* meaning "our canoe."

11 Nobel Prize–winning economist Joseph E. Stiglitz has articulated the dangers of perpetuating dual economies on both global and national levels in *Globalization and Its Discontents* (New York: W. W. Norton, 2002); *The Price of Inequality: How Today's Divided Society Endangers Our Future* (New York: W. W. Norton, 2012); and *The Great Divide: Unequal Societies and What We Can Do about Them* (New York: W. W. Norton, 2015).

12 Homi K. Bhabha, "Framing Fanon," in Fanon, *The Wretched of the Earth*, xii.

13 See Rashid Khaldi, *Palestinian Identity: The Construction of Modern National Consciousness* (New York: Columbia University Press, 1997).

14 Vivan Ziherl, curatorial statement for Jerusalem Show VIII, *Before and After Origins*, IBRAAZ, http://www.ibraaz.org/publications/96.

15 Cave recounts this incident in many interviews, among them Jori Frinkel, "I Dream the Clothing Electric," *New York Times*, March 31, 2009, http://www.nytimes.com/2009/04/05/arts/design/05fink.html.

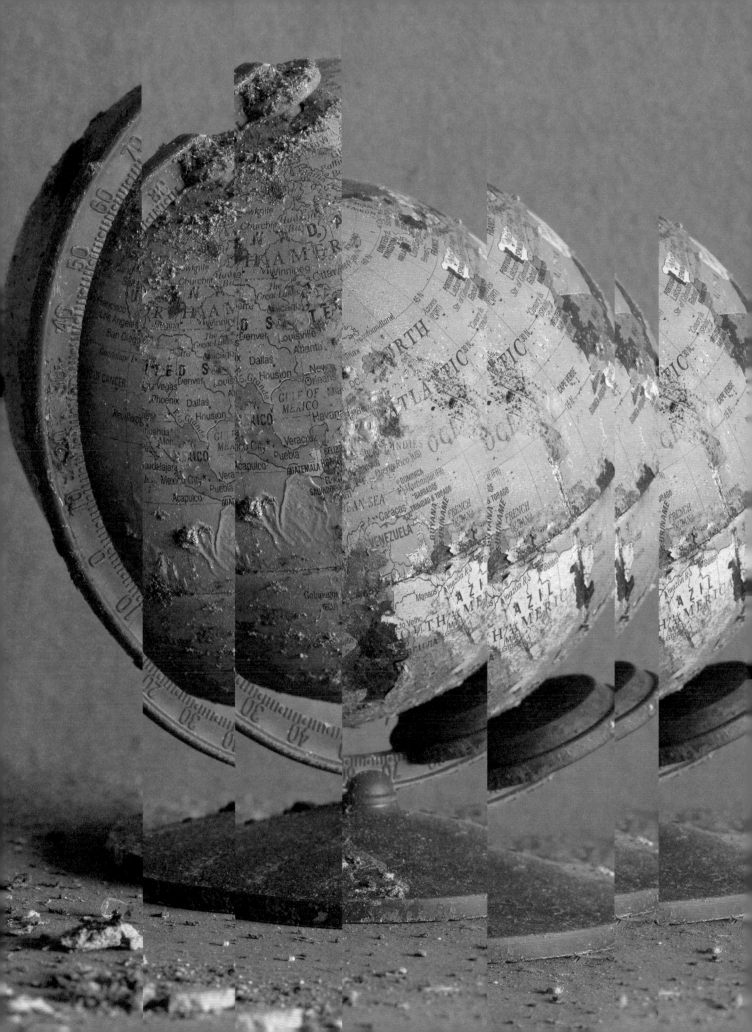

/land
scape
natu
re sp
irit

MARK BRADFORD
As Colors Are Fainting, 2014

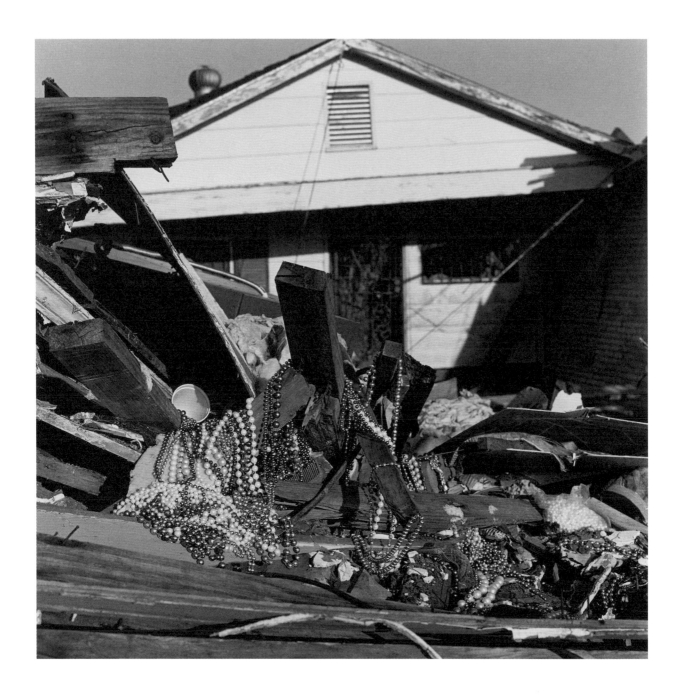

KEVIN BUBRISKI
Untitled from the New Orleans series, 2006

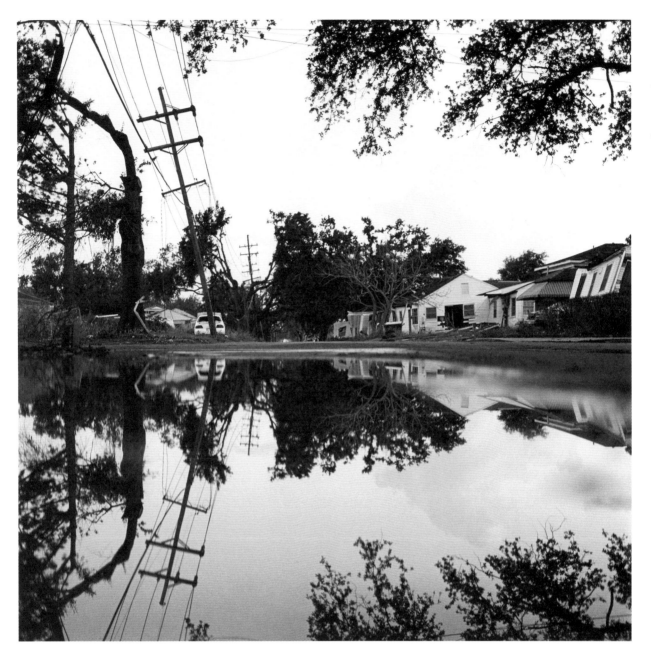

KEVIN BUBRISKI
Untitled from the New Orleans series, 2006

BARBARA CHASE-RIBOUD
She Number One, 1972

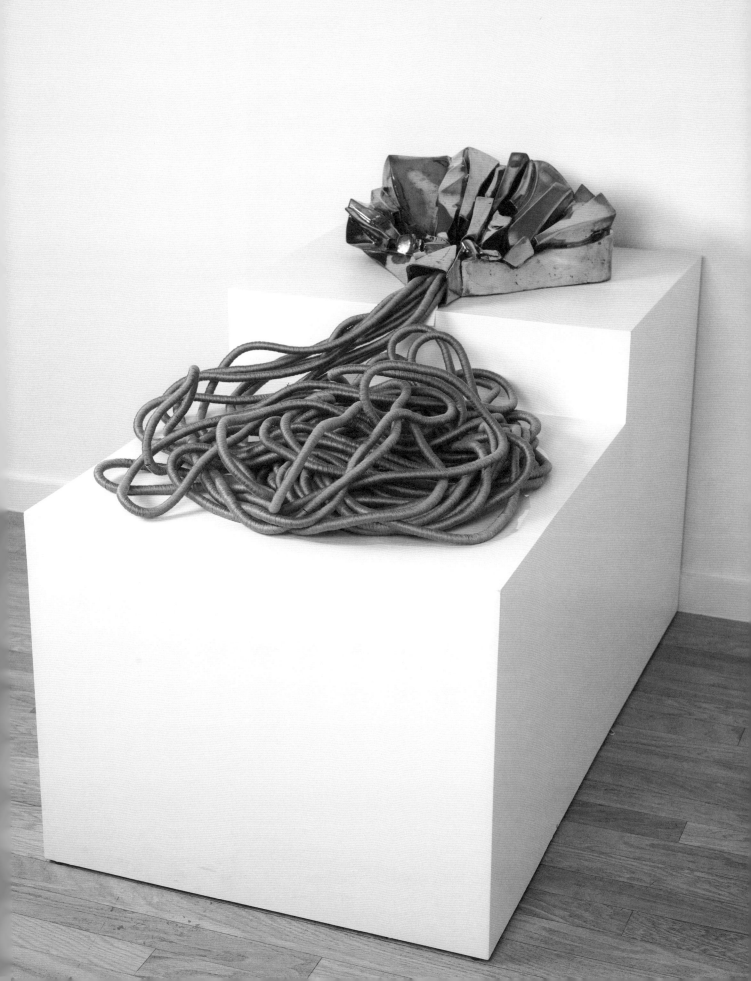

WILLIAM CHRISTENBERRY
Blue Building, Birmingham, Alabama, 1987

WILLIAM CHRISTENBERRY
Red Trucks, Birmingham, Alabama, 1987

WILLIAM CHRISTENBERRY
Railroad Car, Birmingham, Alabama, 1987

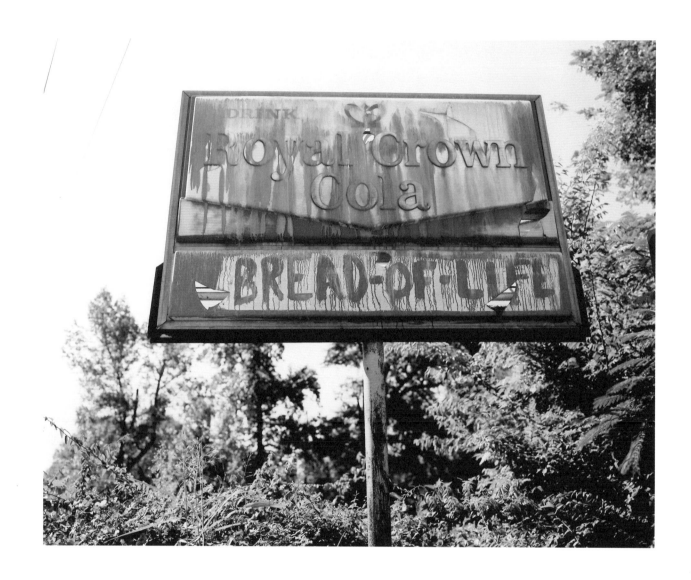

WILLIAM CHRISTENBERRY
"Bread-of-Life," Near Tuscaloosa, Alabama, 1989

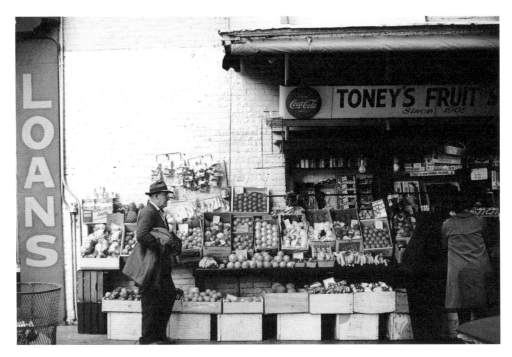

WILLIAM CHRISTENBERRY
Fruit Stand, Sidewalk, Memphis, Tenn., 1966,
1966; printed 1981

WILLIAM CHRISTENBERRY
Processing, Memphis, Tenn., 1966,
1966; printed 1981

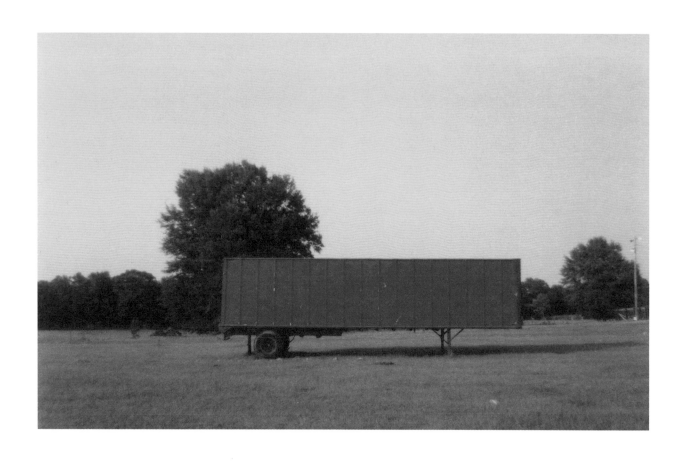

WILLIAM CHRISTENBERRY
Red Trailer, Livingston, Alabama, 1976,
Negative 1976; printed 2002

WILLIAM CHRISTENBERRY
Storefront, Stewart, Alabama, 1962, Negative
1962; printed 2001

WILLIAM CHRISTENBERRY
Parts, near Tuscaloosa, Alabama, 1990,
Negative 1990; printed 1993

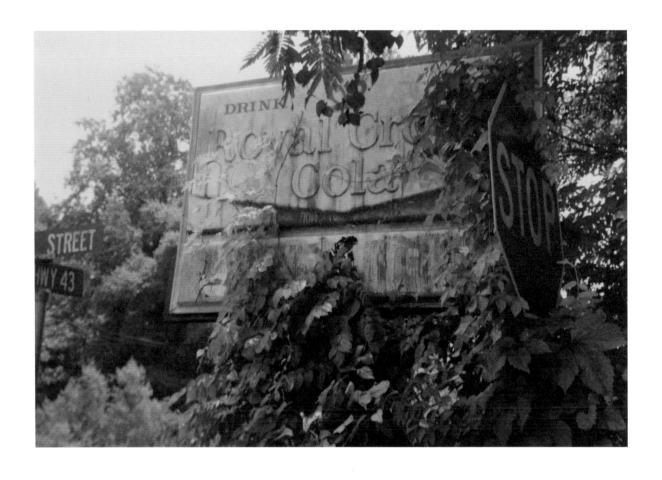

WILLIAM CHRISTENBERRY

"Bread-of-Life," near Tuscaloosa, Alabama,
June 2001, 2001

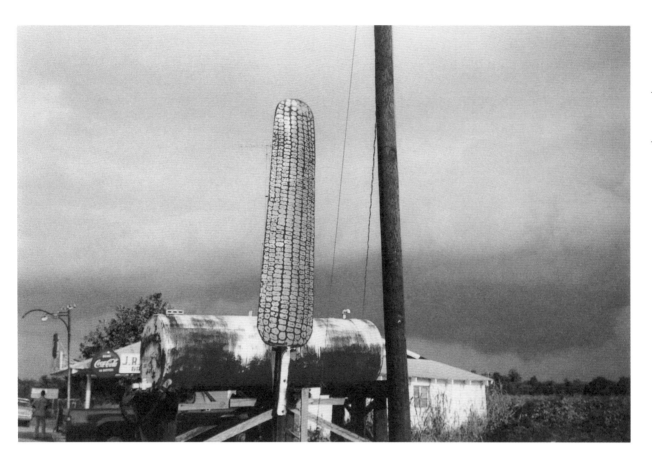

WILLIAM CHRISTENBERRY
Corn Sign with Storm Cloud, Near Greensboro,
Alabama, Negative 1977; printed 1995

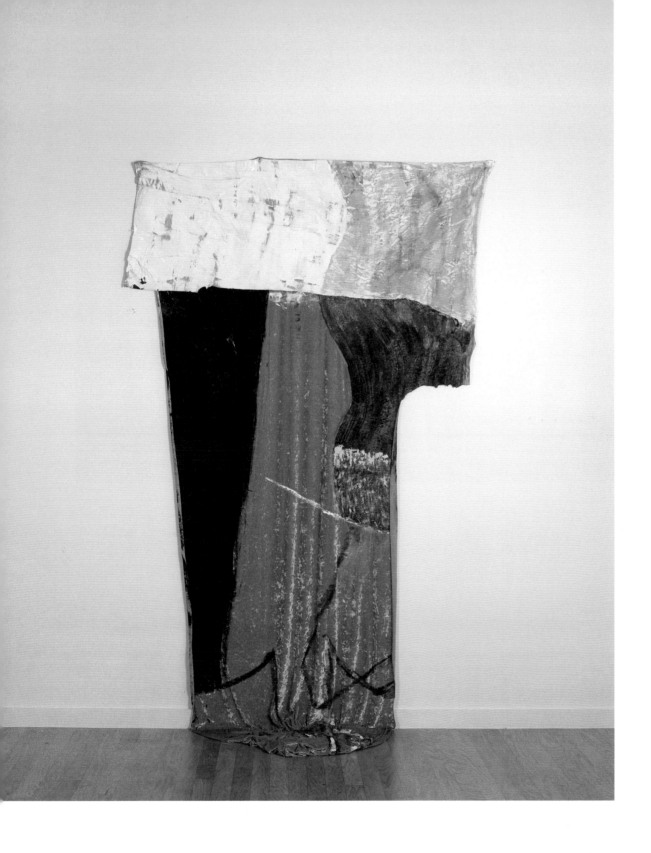

GABY COLLINS-FERNANDEZ
Blue velvet wave painting, 2013

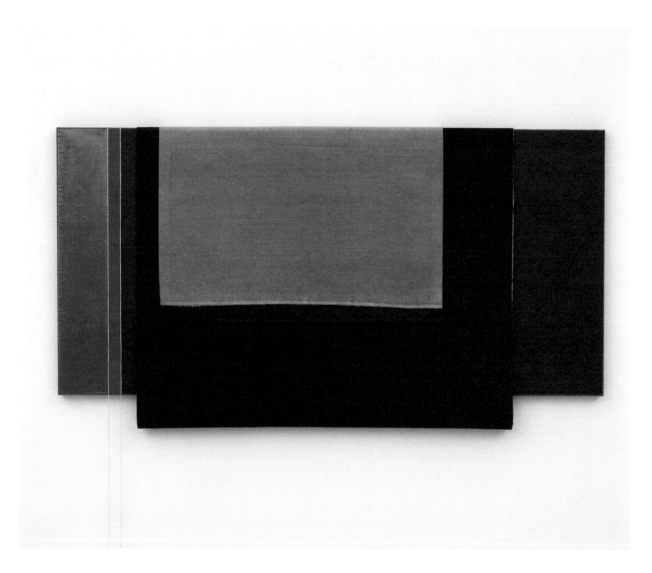

N. DASH
Untitled, 2016

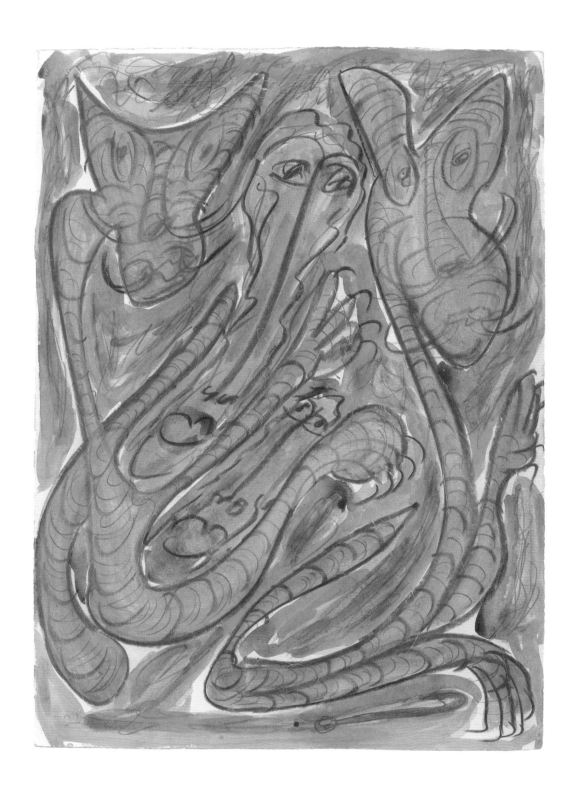

THORNTON DIAL

Paying Attention—Getting Hooked, Undated

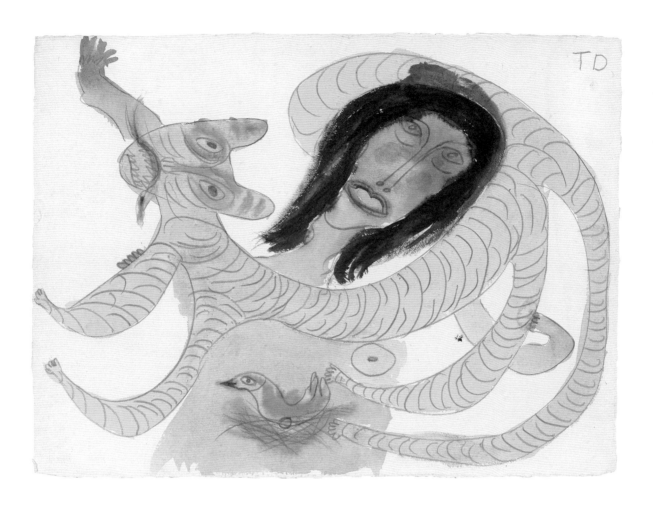

THORNTON DIAL
Lady with her Tiger—Life Go On, 1990

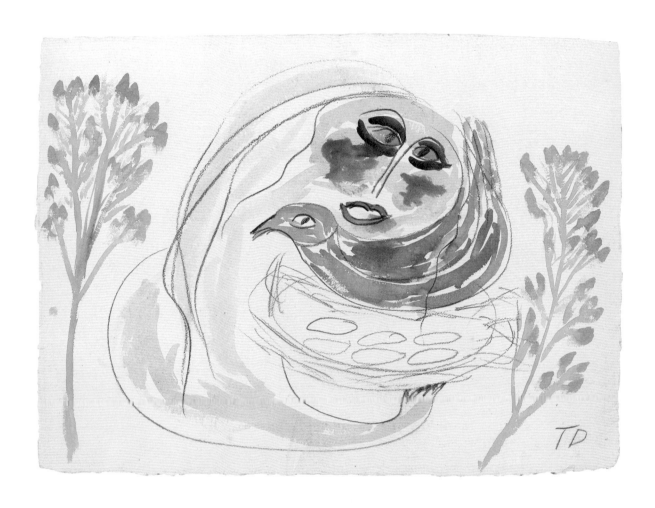

THORNTON DIAL

Lady Holds the Peace Bird, 1990

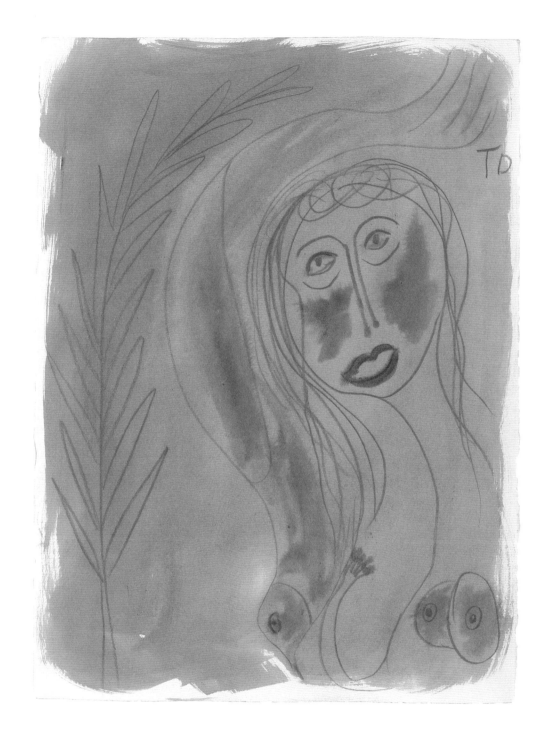

THORNTON DIAL
Life Bird, 1990

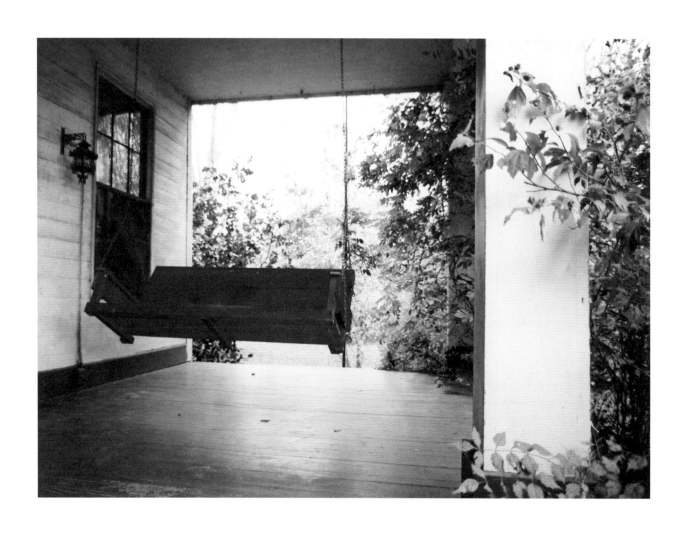

WILLIAM EGGLESTON
Untitled, 1981–82

WILLIAM EGGLESTON
Untitled, 1981–82

WILLIAM EGGLESTON
Untitled, 1981–82

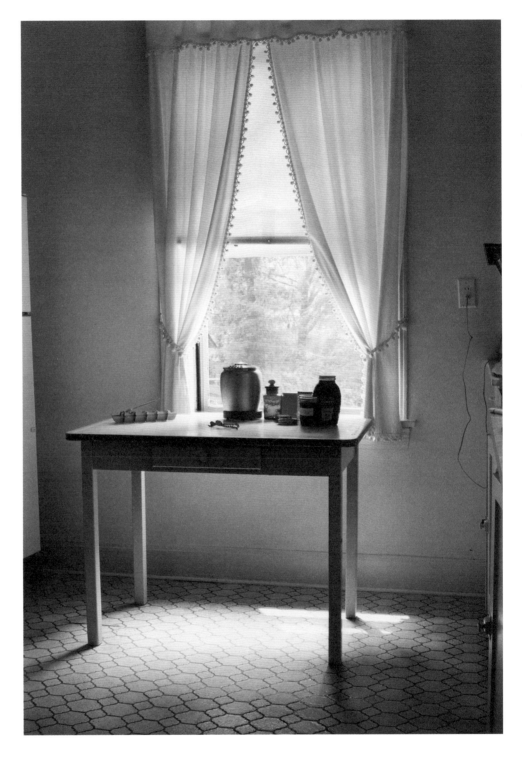

WILLIAM EGGLESTON
Untitled, 1983

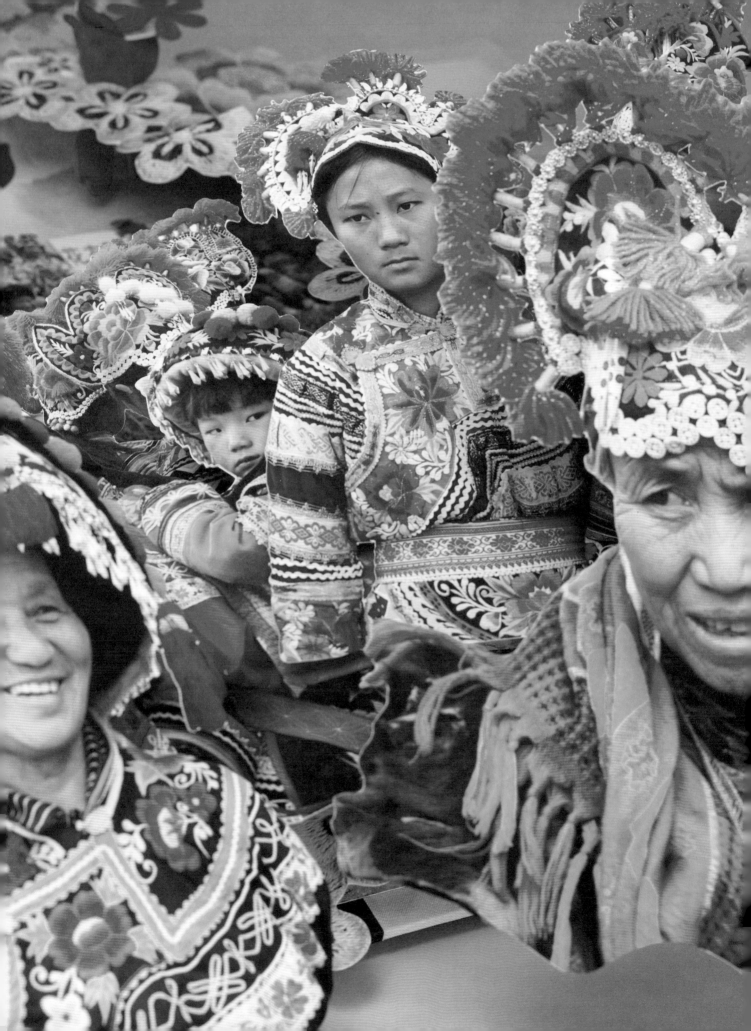

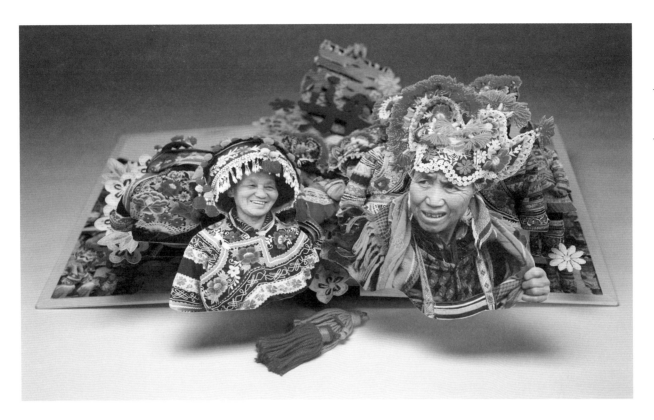

LONNIE HOLLEY
Mystery of the White in Me, 1983

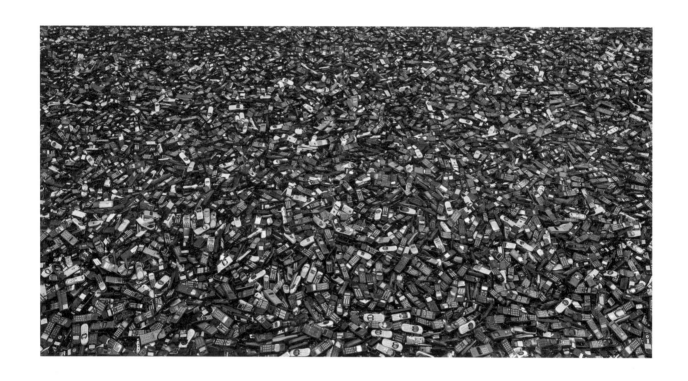

CHRIS JORDAN
Cell Phones, Orlando 2004, 2004

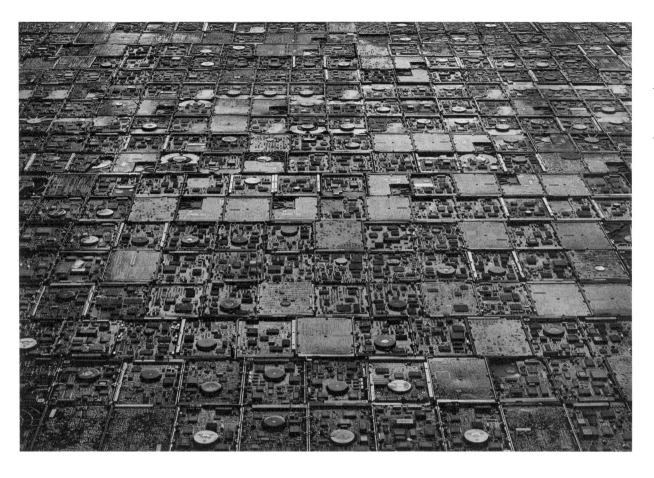

CHRIS JORDAN
Circuit Boards, Atlanta 2004, 2004

CHRIS JORDAN
Sand & Gravel Yard, New Orleans, 2005

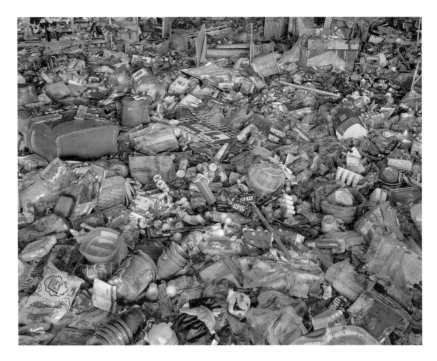

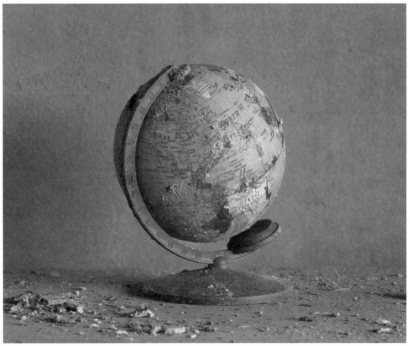

CHRIS JORDAN
Dollar Store near Buras, LA, 2005

CHRIS JORDAN
Globe in Classroom, Chalmette Neighborhood, 2005

R AN AWAY, Glenn. Medium height, 5'8", male. Closely-cut hair, almost shaved. Mild looking, with oval shaped, black-rimmed glasses that are somewhat conservative. Thinly-striped black-and-white short-sleeved T-shirt, blue jeans. Silver watch and African-looking bracelet on arm. His face is somewhat wider on bottom near the jaw. Full-lipped. He's black. Very warm and sincere, mild-mannered and laughs often.

Ran away, Glenn, a black man – early 30's, very short cropped hair, small oval wire-rimmed glasses. Wearing large black linen shirt with white buttons, dark navy shorts, black socks and shoes. Black-and-white bead bracelet and silver watch on left wrist. No other jewelry. He has a sweet voice, is quiet. Appears somewhat timid.

Ran away, Glenn Ligon. He's a shortish broad-shouldered black man, pretty dark-skinned, with glasses. Kind of stocky, tends to look down and turn in when he walks. Real short hair, almost none. Clothes non-descript, something button-down and plaid, maybe, and shorts and sandals. Wide lower face and narrow upper face. Nice teeth.

R AN AWAY, Glenn, 5'7" – 5'9", Medium– small build, say 160 lbs. Black linen shirt (with white "C.P. Company" label on skirt of shirt), white buttons. Dark blue-black jean shorts, black socks, low-top black leather shoes with rubber soles (vibram). African-American, with very short cut hair. About 30 years old. Wears glasses – oval shaped, wire (black) rims, tortoise shell effect on the sides. Watch with silver strap, bracelet: black-and-white.

R AN AWAY, Glenn. He is black. He has very short hair and eye glasses. He has quite light skin tone (faded bronze). Not tall. No noticeable accent. Wearing a plum-colored shirt, long-sleeved, and shorts. Very casual and stylish in appearance. He is wearing a bead bracelet (stones – a mixture of black-and-white). He has big hands and fingers. When he walks his feet cross each other a little bit. When he talks, he usually has a big smile towards you, yet he faces you from a slightly different angle. He looks at you from the corner of his eyes. His voice is very calm.

R AN AWAY, a man named Glenn. He has almost no hair. He has cat-eye glasses, medium-dark skin, cute eyebrows. He's wearing black shorts, black shoes and a short sleeve plaid shirt. He has a really cool Timex silver watch with a silver band. He's sort of short, a little hunky, though you might not notice it with his shirt untucked. He talks sort of out of the side of his mouth and looks at you sideways. Sometimes he has a loud laugh, and lately I've noticed he refers to himself as "mother."

GLENN LIGON
Runaways, 1993

RAN AWAY, Glenn, a young black man twenty-eight years old, about five feet six inches high. Dressed in blue jeans, a blue button-down shirt, black shoes. Medium build. Very short haircut (not quite shaved head). Large neck. Green tinted sunglasses.

RAN AWAY. Young guy – the Oliver North of downtown. 5 feet, + and then some. Medium build, stylishly casual (usually in jeans). Soft-spoken, well-spoken but kinda' quiet. Wears delicate glasses. Moves smoothly, looks like he might have something on his mind – he'll find you.

RAN AWAY, a man named Glenn, five feet eight inches high, medium-brown skin, black-framed semi-cat-eyed glasses, close-cropped hair. Grey shirt, watch on left hand. Black shorts, black socks and black shoes. Distinguished looking.

RAN AWAY, Glenn, a black male, 5'8", very short hair cut, nearly completely shaved, stocky build, 155-165 lbs., medium complexion (not "light skinned," not "dark skinned," slightly orange). Wearing faded blue jeans, short sleeve button-down 50's style shirt, nice glasses (small, oval shaped), no socks. Very articulate, seemingly well-educated, does not look at you straight in the eye when talking to you. He's socially very adept, yet, paradoxically, he's somewhat of a loner.

LARISSA LOCKSHIN
Untitled (Reviewer), 2015

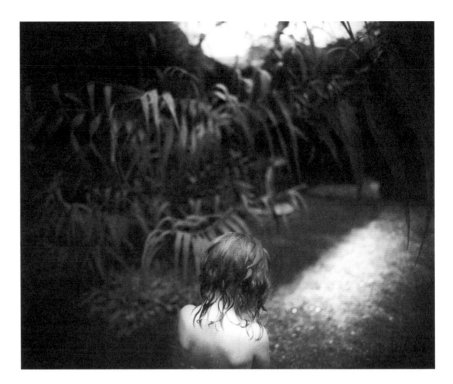

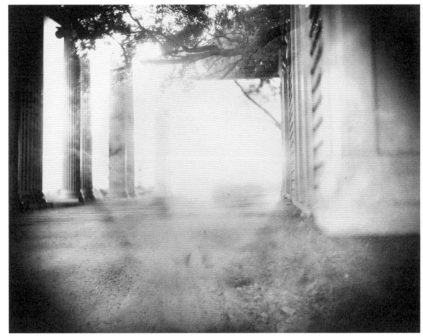

SALLY MANN
Arundo Donax, 1988

SALLY MANN
Untitled, About 1998

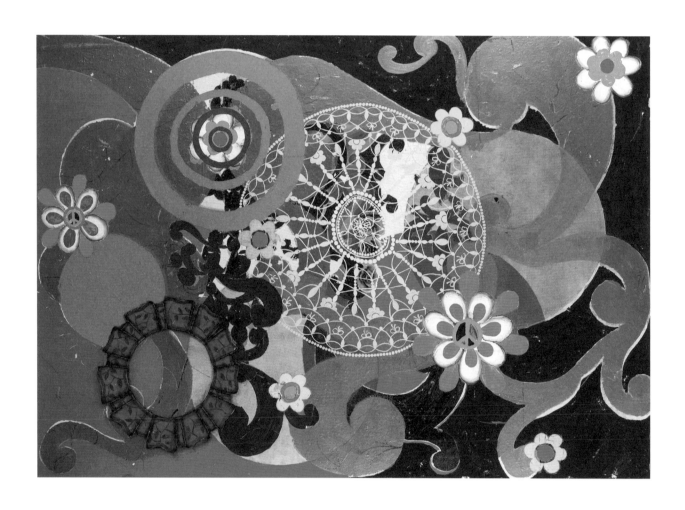

BEATRIZ MILHAZES
A Infanta, 1996

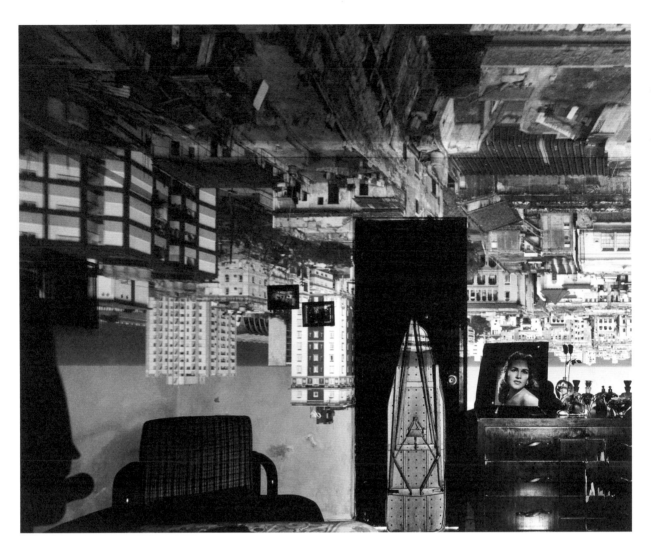

ABELARDO MORELL
Camera Obscura Image of El Vedado, Habana,
Looking Northwest, Cuba, 2002

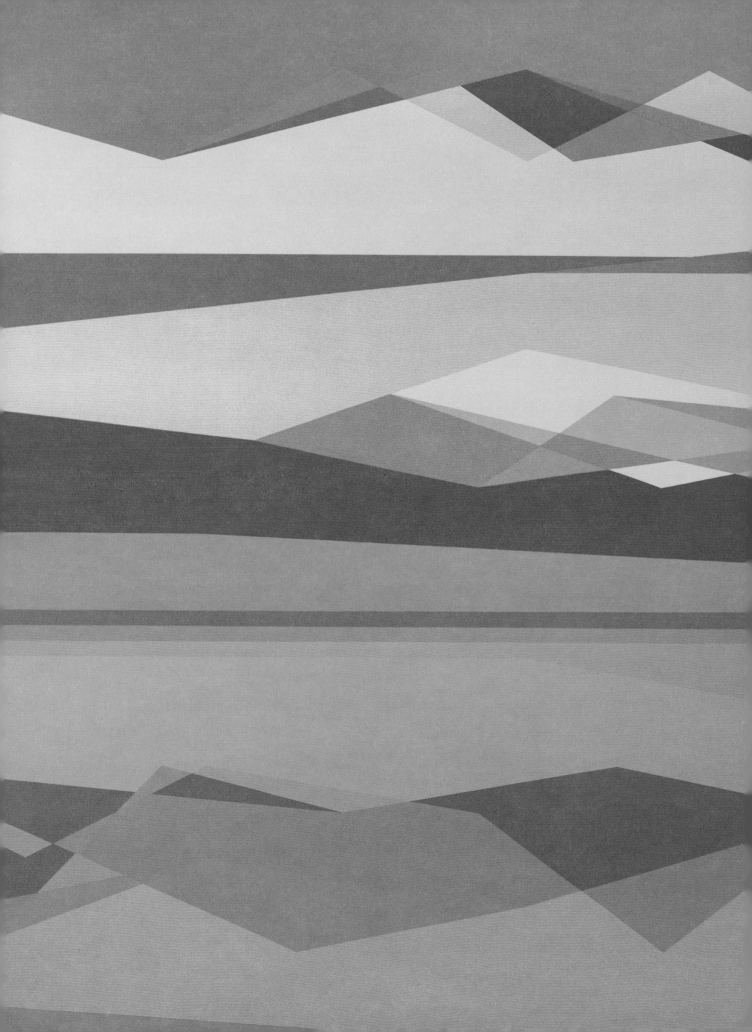

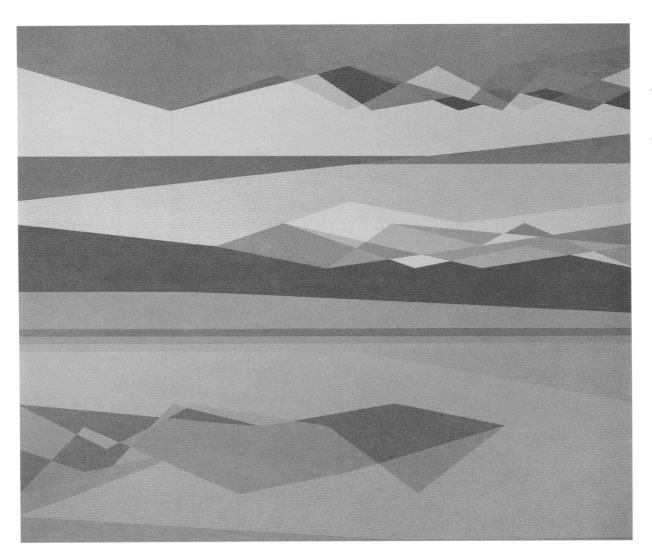

ODILI DONALD ODITA
Gravity's Rainbow, 2001

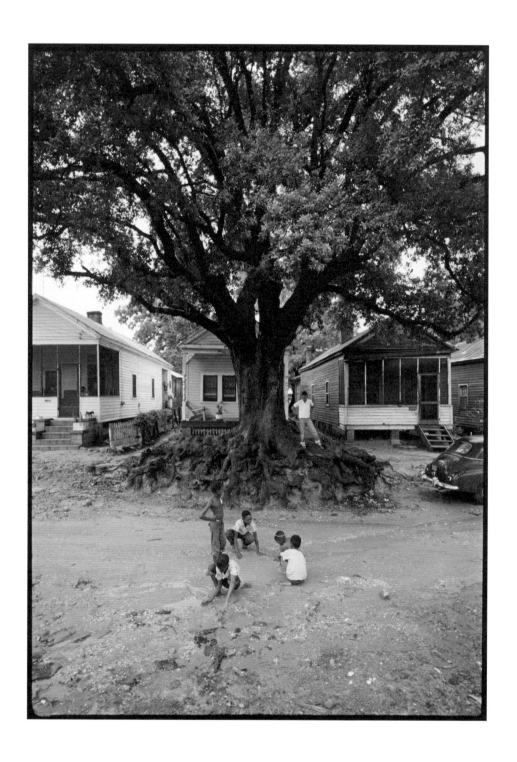

GORDON PARKS

Children at Play, Mobile, Alabama, 1956, 1956

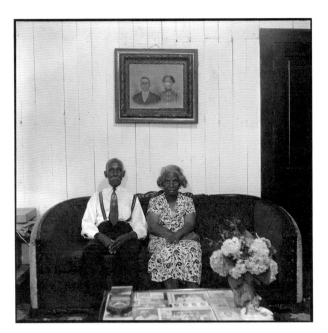

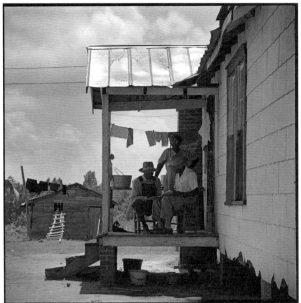

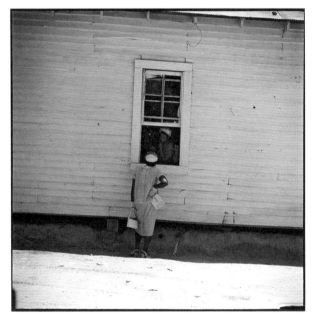

GORDON PARKS
Mr. and Mrs. Albert Thornton, Mobile,
Alabama, 1956, 1956

GORDON PARKS
Untitled, Mobile, 1956, 1956

GORDON PARKS
Untitled, Shady Grove, 1956, 1956

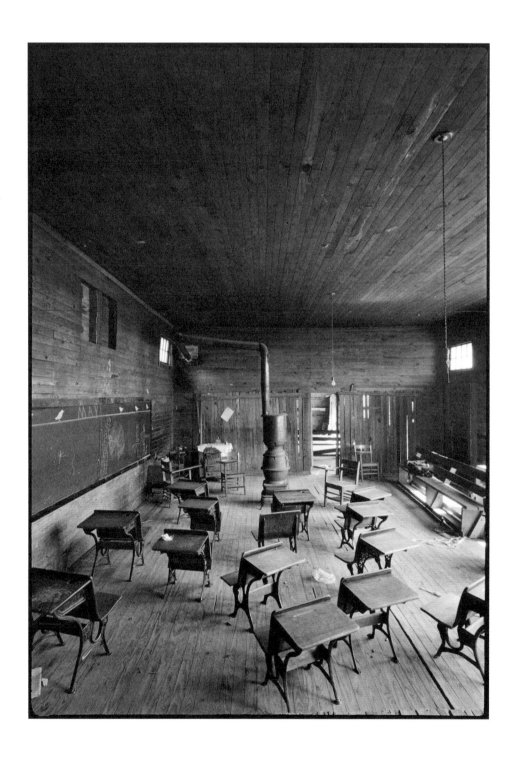

GORDON PARKS
Black Classroom, Shady Grove, Alabama,
1956, 1956

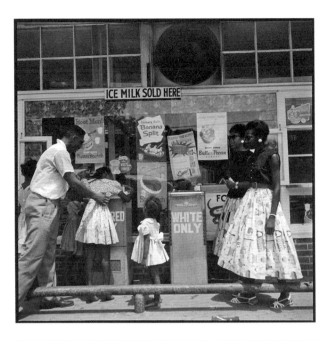

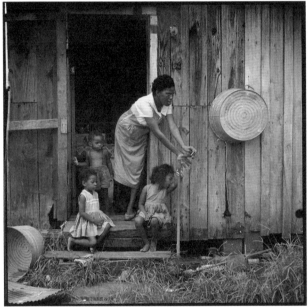

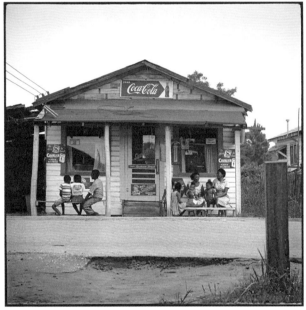

GORDON PARKS
At Segregated Drinking Fountain, Mobile, Alabama, 1956, 1956

GORDON PARKS
Mother and Children, Mobile, Alabama, 1956, 1956

GORDON PARKS
Store Front, Mobile, Alabama, 1956, 1956

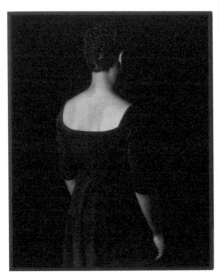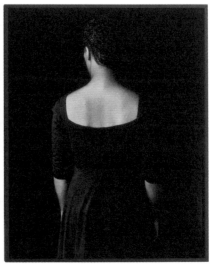

present

past imperfect present imperfect

past perfect future perfect

LORNA SIMPSON
Tense, 1991

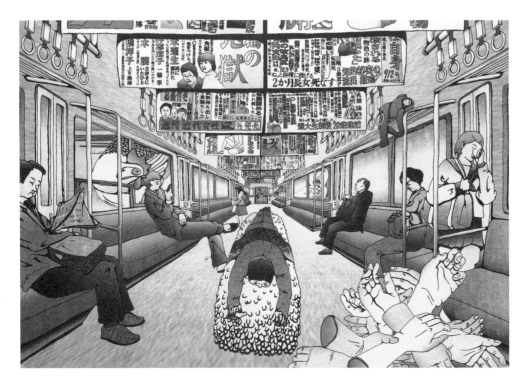

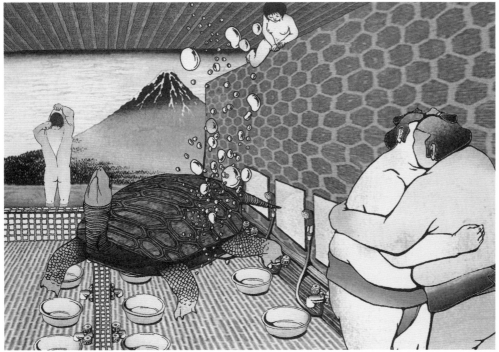

TABAIMO
Railway Track, 2003

TABAIMO
Men's Bathhouse, 2003

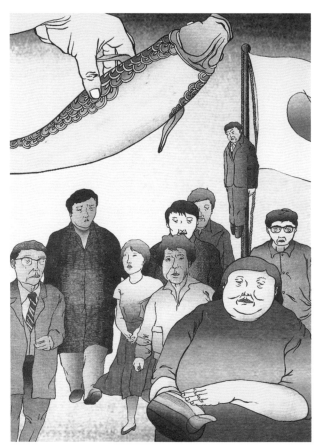

TABAIMO
Raise Your Flags and Walk Along the Pedestrian Crossing, 2003

TABAIMO
Sutra and Child's Leg, 2003

TOREY THORNTON
Time Lapsed Lapping, 2015

JUAN USLÉ
Zozobras en el Jardín (Rumors in the Garden), 1999

XAVIER VENDRELL, STEVE LONG,
RURAL STUDIO, AUBURN UNIVERSITY
2x's, 2016

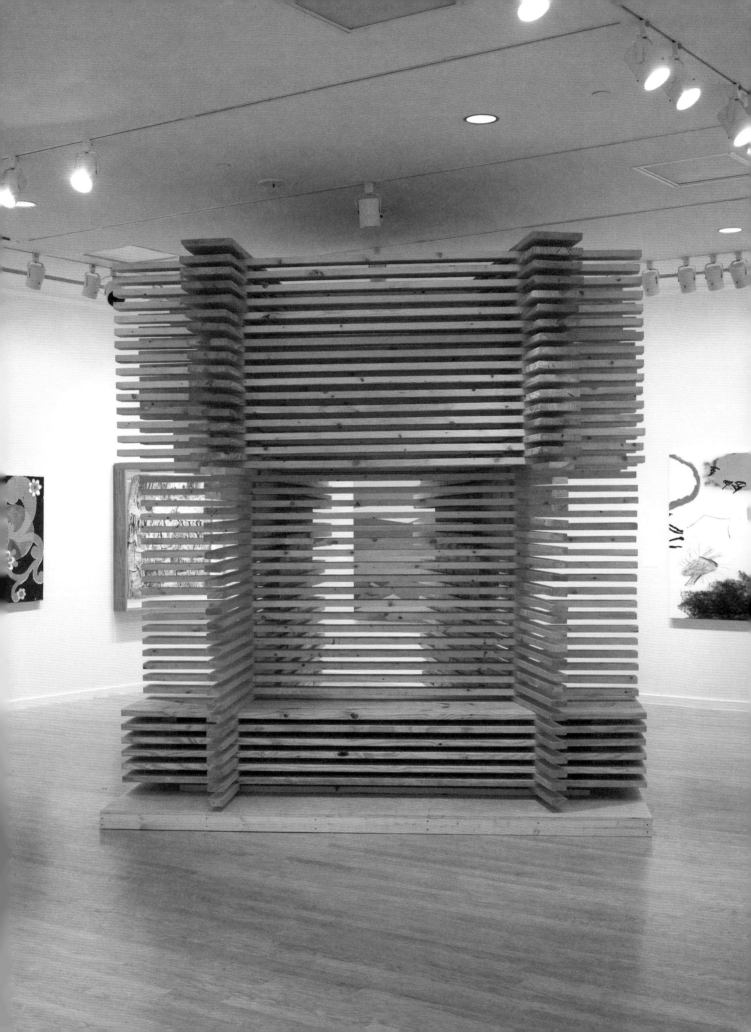

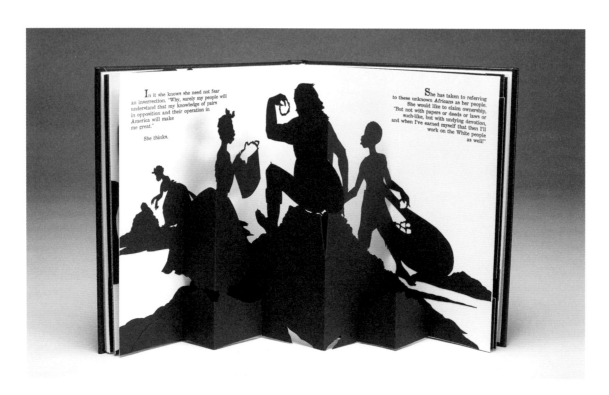

In it she knows she need not fear an insurrection. "Why, surely my people will understand that my knowledge of pairs in opposition and their operation in America will make me great."

She thinks.

She has taken to referring to these unknown Africans as her people. She would like to claim ownership, "But not with papers or deeds or laws or such-like, but with undying devotion, and when I've earned myself that then I'll work on the White people as well!"

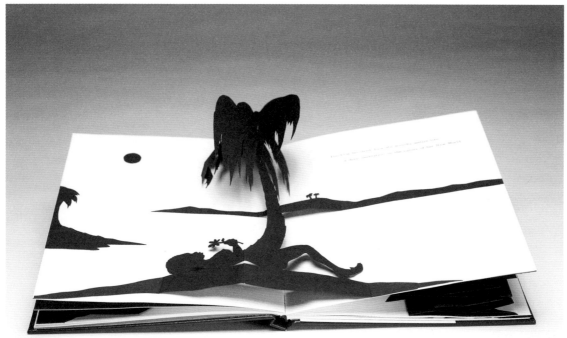

KARA WALKER
Freedom: A Fable, 1997

CARRIE MAE WEEMS
The Tragedy of Hiroshima, 2008

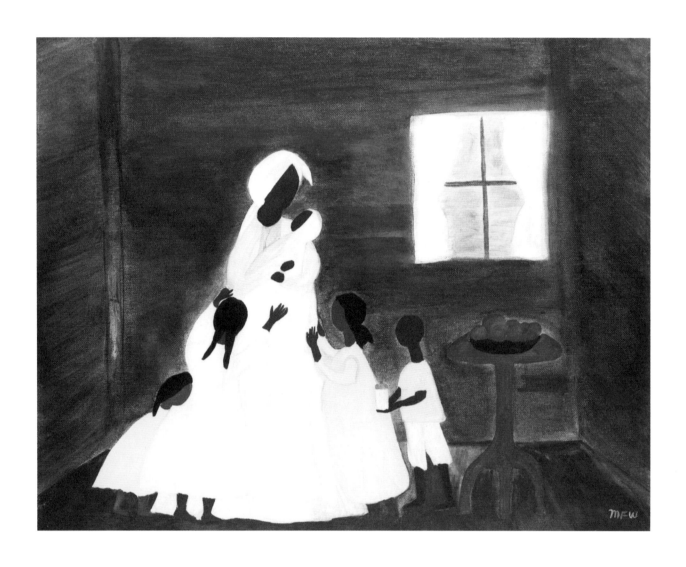

MARY WHITFIELD
Love, 1991–94

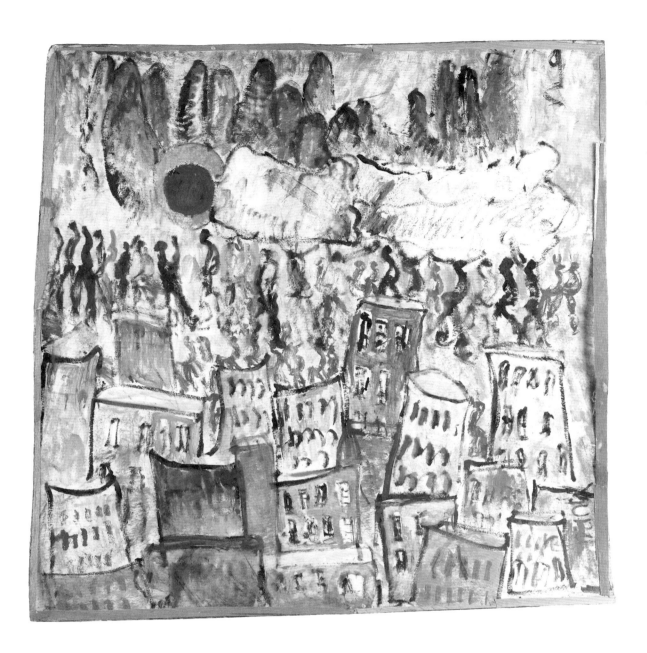

PURVIS YOUNG
Burial Over the City, About 1990

Lindsey Reynolds

/publication_as_practice

All of the publications featured in *Third Space* act as markers of the Global South, either by virtue of their geography or the thematic explorations they contain. The essential narrative and sequential qualities of a book is sometimes celebrated and sometimes manipulated to make a point about the structured narrative of contemporary society. These publications feel familiar and share a common vernacular. Most incorporate hand-painted or woodblock letters and explore themes like music and religion. They engage language and question the authenticity of the stories we are told about who we are, where we come from, and how we got to where we are now. Almost all of them nod to the past, to both shared and distinct histories. Some, like Kara Walker's *Freedom: A Fable* (1997), evidence a fascination with the visual motifs of a society that marks them as other. These artists' books encompass the spectrum of *Third Space* and deliver its concepts in an intimate and digestible format.

The physical structure of these books, the sequential order imposed by turning pages, the narrative quality of that sequence, and the authority that the act of publishing assumes provide fertile ground for artistic output. In most cases, these books are not the sole medium of a particular artist, nor do they supersede their primary studio practice. Instead they act as vehicles for ideas, means to disseminate information, and affordable ways to explore with urgency. The zines in the exhibition are representative of the wider genre's emphasis on a do-it-yourself attitude. A gritty aesthetic vouches for the authenticity and immediacy of the content within.

The low budget cost to produce a zine furthers the ideal of self-representation for even the most emergent of authors.

Artists' books rose to prominence in the United States in the 1960s as a way to bypass traditional art world institutions and to get artwork directly into the hands of an audience. Critics and acolytes alike struggled with a definition for this new medium. There is no singular definition; they are often more easily described by what they are not rather than what they are. One prominent artists' book scholar has stated that their "popularity can probably be attributed to the flexibility and variation of the book form, rather than to any single aesthetic or material factor."[1] At the beginning, books by artists were perceived as a potentially revolutionary means of communication: a way to break down the barriers between artist and public, to democratize the art world, or at least to give artists direct access to their audiences and to share their work and ideas without an institutional filter. They were cheap to produce, could be duplicated in vast numbers, and distributed wherever books were sold.

Not every book in this exhibition falls into the twentieth-century definition of an artist's book as a democratic multiple, but like their more procreant relatives, they also serve to document histories and traditions, often from a lesser heard perspective. These works anchor the other end of the publishing spectrum, the traditional craft of handmade books. Islam Aly is one such book artist. He uses ancient book binding techniques to explore the present moment in *The Square* (2014), an Ethiopian and Coptic bound book that focuses on the slogan "al-sha`b yurid isqat al-nizam" [The people want to bring down the regime]. This was the slogan chanted by demonstrators across the Arab world in a revolutionary wave now known as the Arab Spring. Aly burnt the text into the paper, recalling the myth of the phoenix and the hope that a new society would emerge from the ashes of the revolution. Tahrir Square, a large public square in downtown Cairo, became a central symbol of the 2011 Egyptian revolution and of the Arab Spring. The book's square format echoes the architecture of the public square. The space of the book becomes a space to share the ideas of the resistance in the same way that the physical square was a space for the people to gather.

The Office of Culture and Design's publication *Filipino Folk Foundry* (2015) also attempts to document a moment, or in this case, a culture in time. It is a catalogue of contemporary Filipino sign painters, and as such, it acts as an encyclopedia of a vanishing subculture. In the text, each painter's work is accompanied by a standardized set of questions describing the painter's personal

style and inspiration. The reader is forced to recognize the artists behind the visual culture of a city, to notice what might otherwise be just another sign. The spiral-bound book is printed on newsprint in a nod to the ephemeral nature of these artists' output. The weather in Manila is hardly conducive to the long-term survival of hand-painted signs or of paper, for that matter. More than that, it fights for the recognition of local culture in the face of colonization and globalization. In fact, one of the stated goals of the Office of Culture and Design's publishing branch, Hardworking Goodlooking, is to "'decolonize Philippine aesthetics' through promoting and implementing the often overlooked contemporary vernacular."

Lonnie Holley's vinyl records evidence another way that artists use publishing to reclaim their voice. They show his multidisciplinary approach to creation in which he creates the music himself and often performs it in both music and art venues. *Just Before Music*'s (2013) cover shows Holley standing with a group of his sandstone sculptures. His wide eyes and colorful costume reference another Birmingham native, the legendary Sun Ra. In seeking to align himself with an artist whose talent and output defied categorization, Holley claims the right to charter new territory in his own practice.

notes

1 Lucy R. Lippard, "Conspicuous Consumption: New Artists' Books," in *Artists' Books: A Critical Anthology and Sourcebook*, ed. Joan Lyons (Rochester, NY: Visual Studies Workshop, 1985).

2 Madeleine Morley, "Why Self-publishing Is a Decolonizing Act in the Philippines," February 13, 2017, https://eyeon design.aiga.org/why-self -publishing-is-a-decolonizing -act-in-the-philippines/.

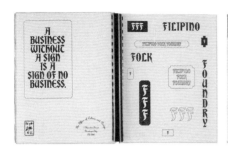

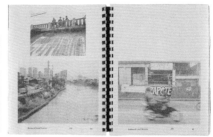

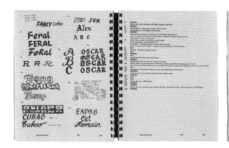
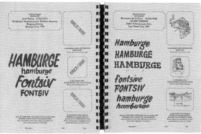
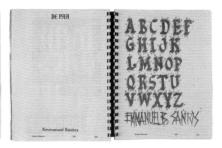

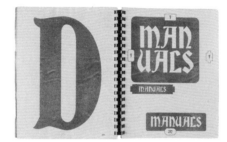

CLARA BALAGUER
Filipino Folk Foundry (2nd Edition), 2015

WES FRAZER
The Black Belt, 2013–15

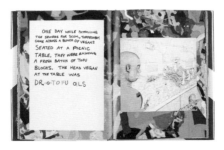

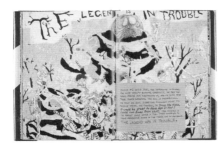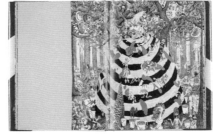

TRENTON DOYLE HANCOCK
Me a Mound, Published 2005

LONNIE HOLLEY
Just Before Music, 2013

LONNIE HOLLEY
Keeping a Record of It, 2013

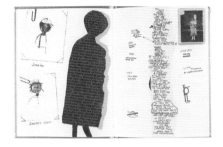

RUTH LAXSON
A Hundred Years of: LEX FLEX, 2003

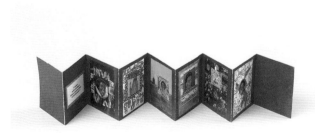

BURGIN MATHEWS
Reverend Mister Gate Mouth: The One Who Buried Sin / The Death & Life of "Gatemouth" Moore, 2013

BURGIN MATHEWS
Thirty Birmingham Songs, 2011

BURGIN MATHEWS
LIVE! At the Alabama Women's Prison / Mack Vickery & The Julia Tutwiler Blues, 2014

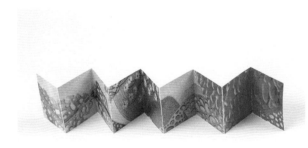

JESSICA PETERSON
An Homage to the Divas of the Aisles of Kymberlyn Compare Foods Grocery, 2004

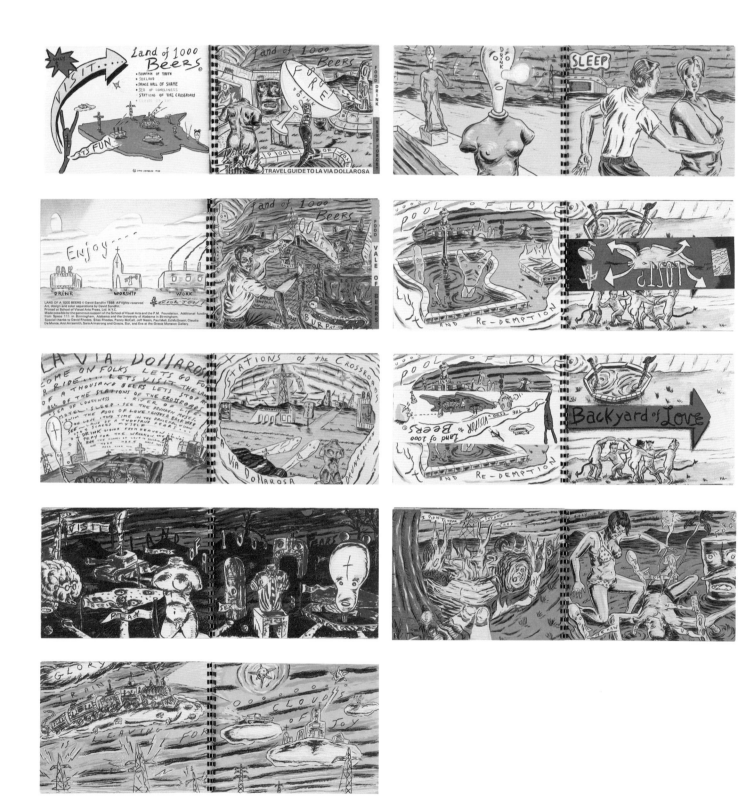

DAVID SANDLIN

Land of 1000 Beers: Travel Guide to La Via Dollarosa, 1989

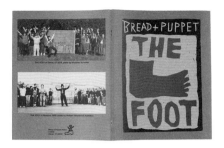

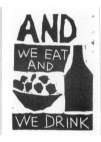

PETER SCHUMANN
The Foot, 2002

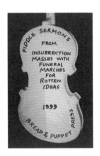
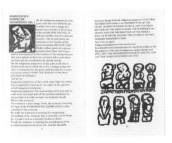

PETER SCHUMANN
*The Fiddle Sermons from the Insurrection
Masses with Funeral Marches for Rotten
Ideas*, 1999

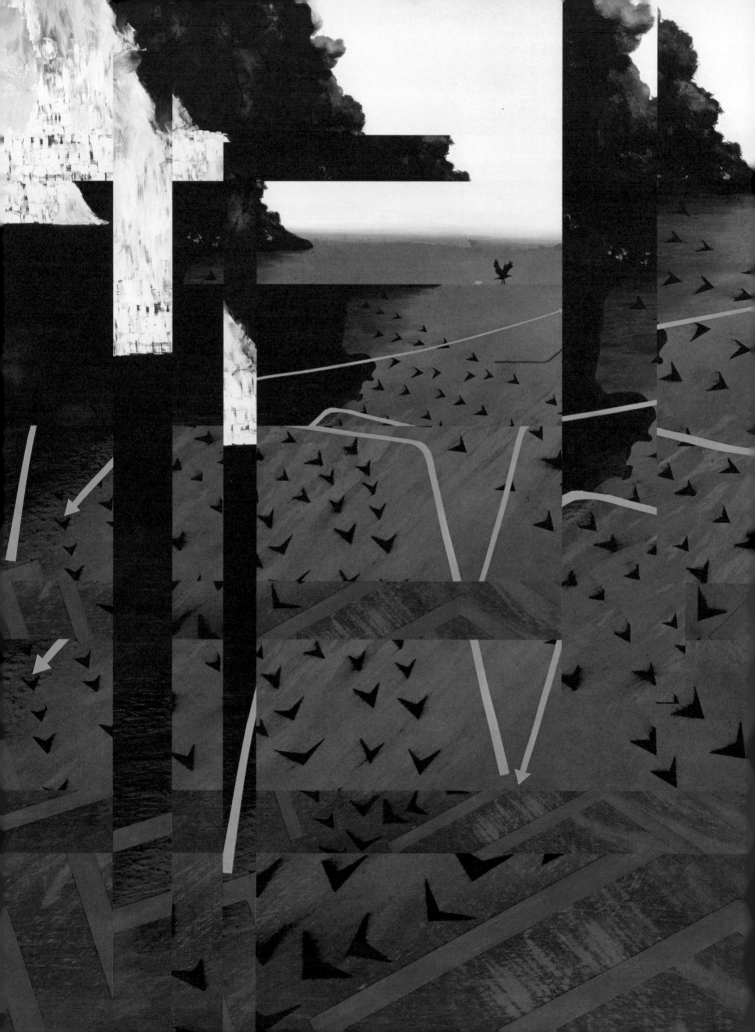

/tradition_history_memory

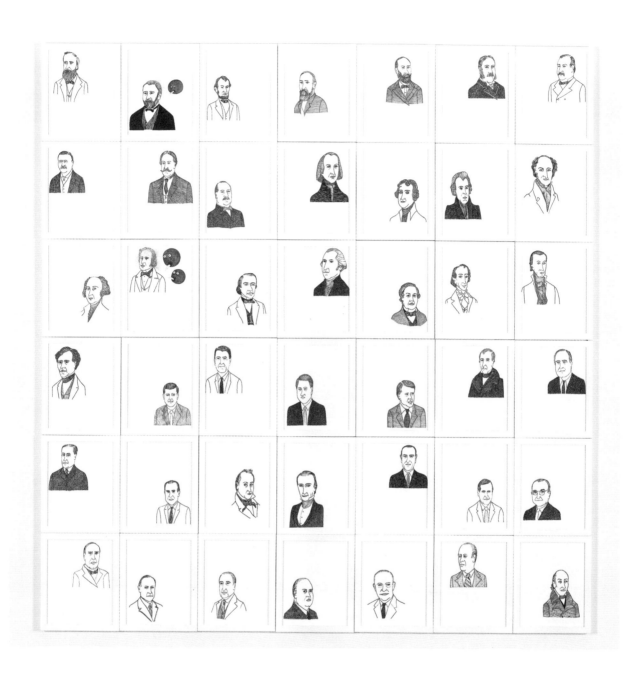

LAYLAH ALI
Presidents, 1994–96

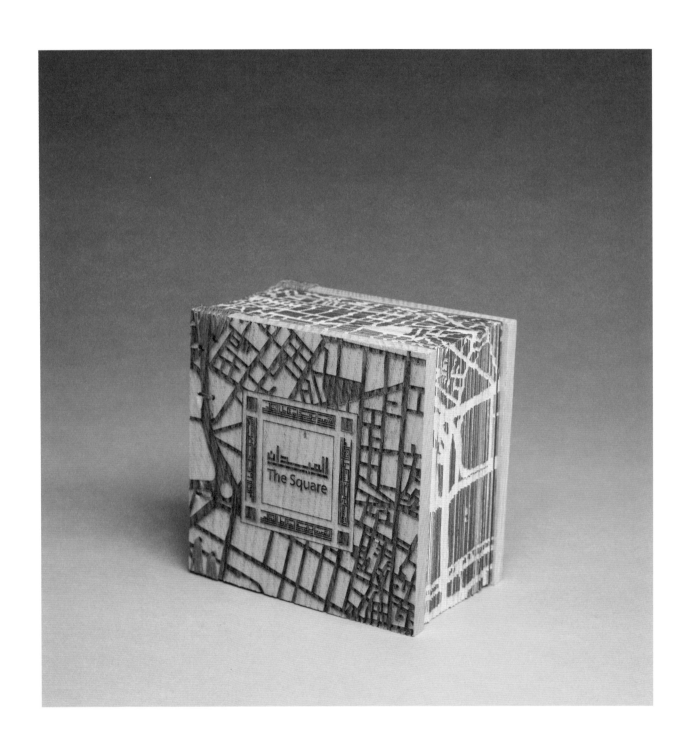

ISLAM ALY
The Square, Al Midan, 2014

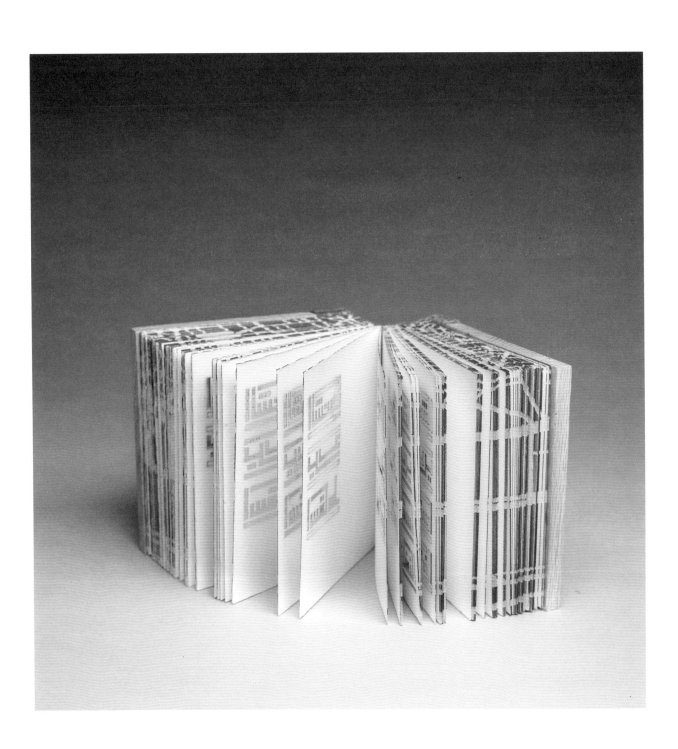

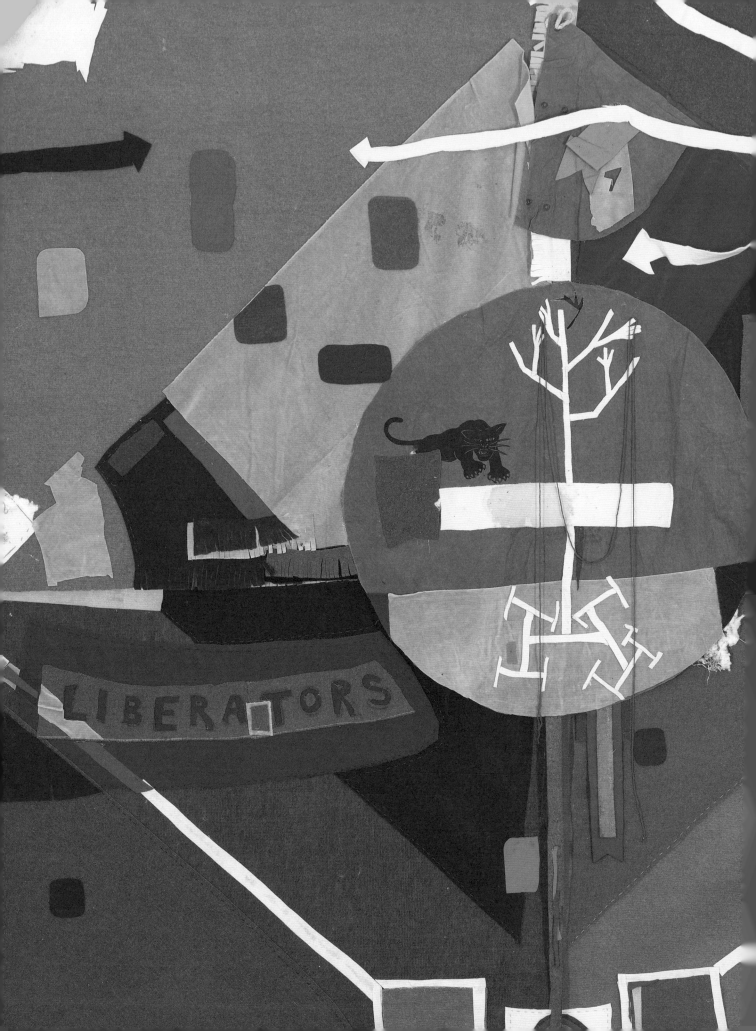

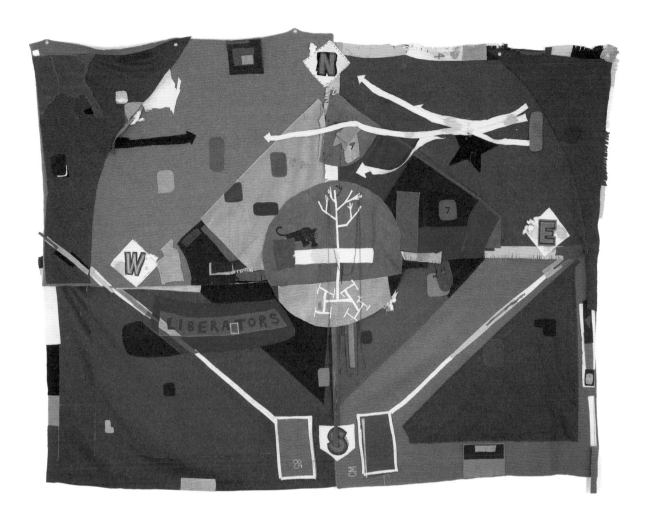

RADCLIFFE BAILEY
Black Diamond, 2007

JOSÉ BEDIA
Mpangui jimagua (Twin Brothers), 2000

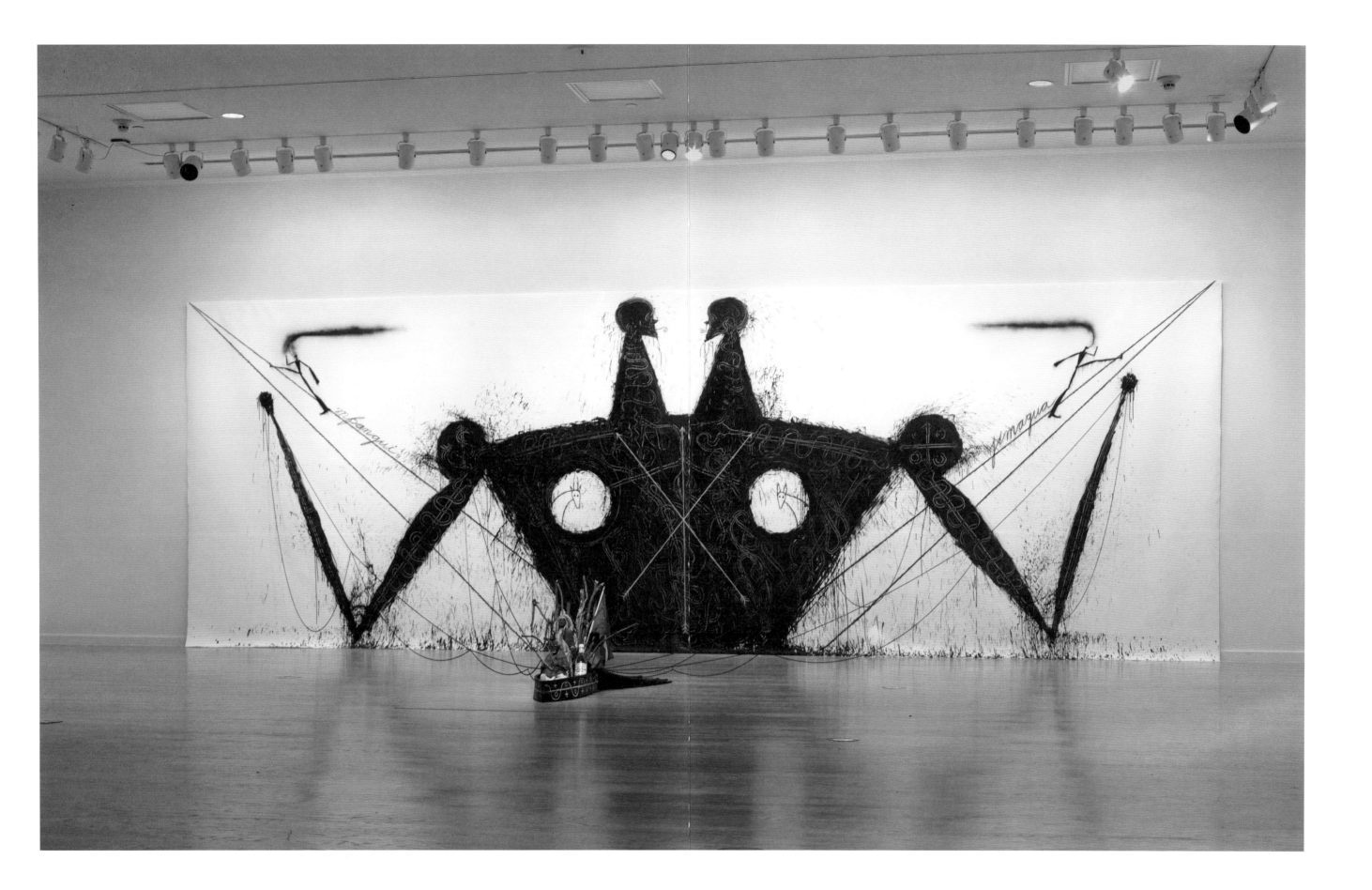

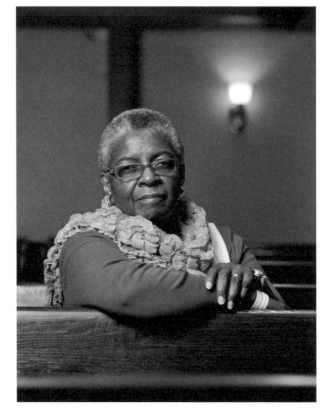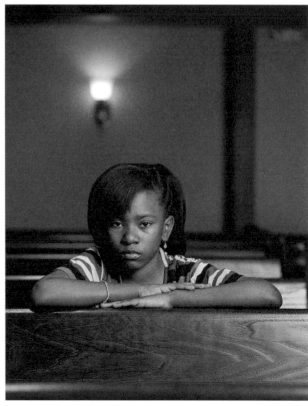

DAWOUD BEY
Mary Parker and Caela Cowan, 2012

176

DAWOUD BEY
Braxton McKinney and Lavone Thomas, 2012

DAWOUD BEY
Taylor Falls and Deborah Hackworth, 2012

DAWOUD BEY
Don Sledge and Moses Austin, 2012

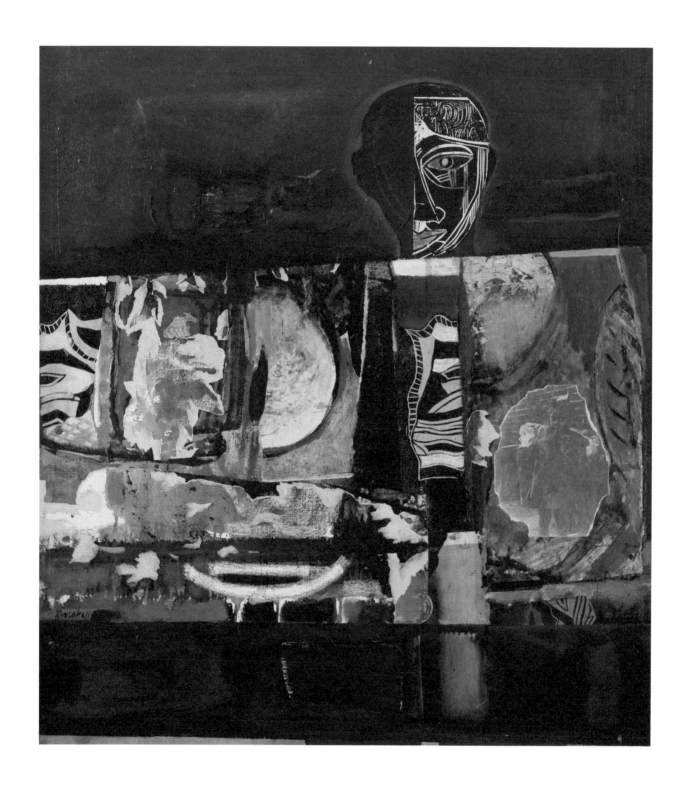

DAVID C. DRISKELL
Ghetto Wall #1, 1971

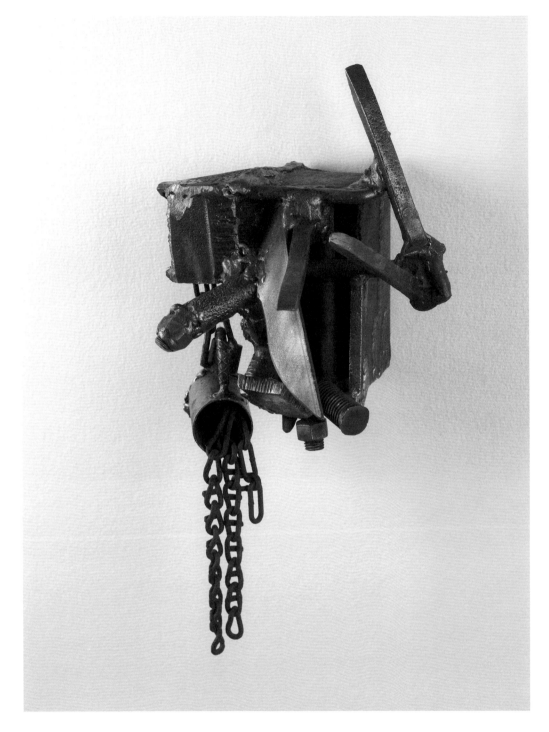

MELVIN EDWARDS
Premonition from the Lynch Fragment Series, 1990

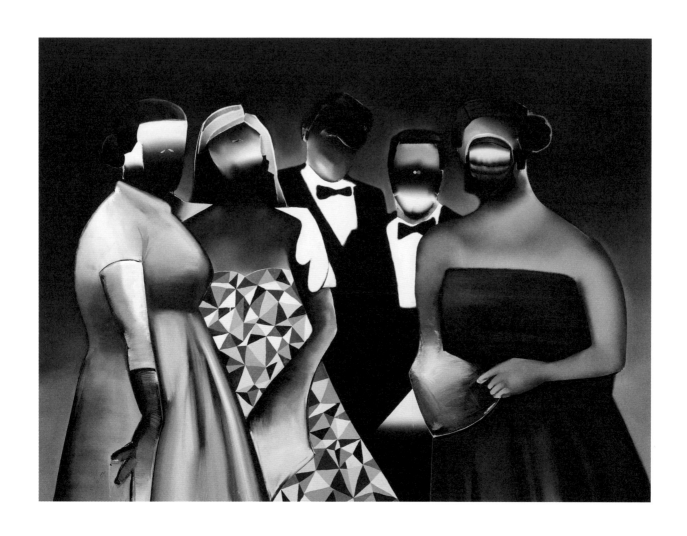

TOMOO GOKITA
Be Just Like Family, 2015

**TIM ROLLINS
AND K.O.S. (KIDS OF SURVIVAL)**
Invisible Man (after Ralph Ellison), 1999–2000

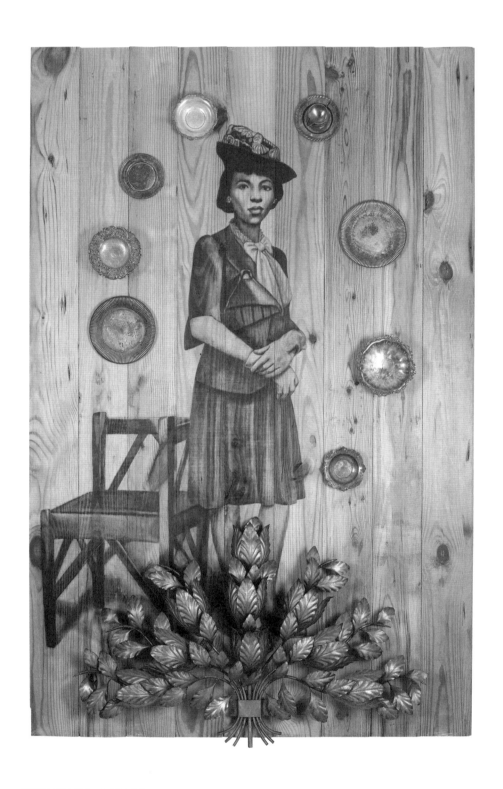

WHITFIELD LOVELL
Rise of the Delta, 2013

KERRY JAMES MARSHALL
As Seen on TV, 2002

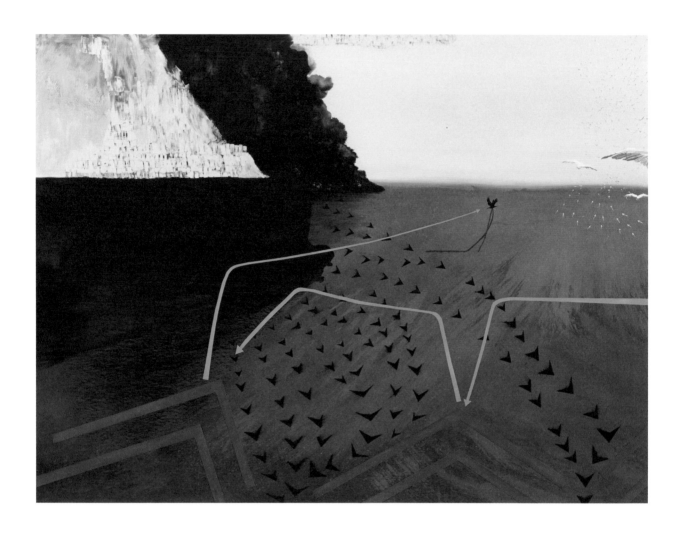

MERRITT JOHNSON
Crow booming the One Big Water, Gulls flying away, 2010

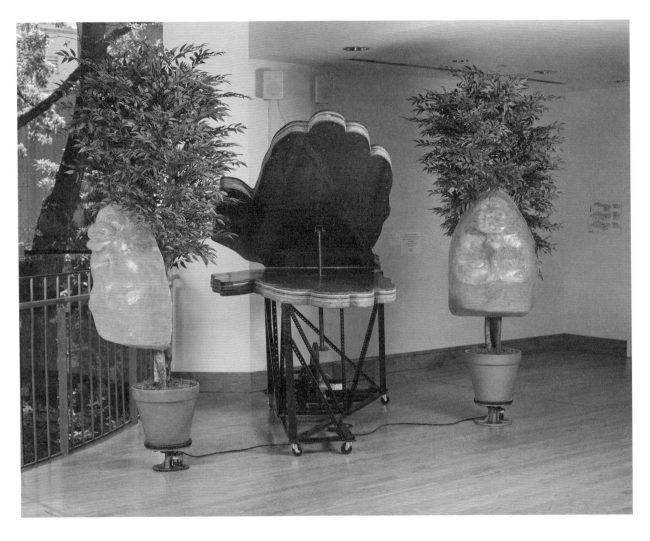

DENNIS OPPENHEIM
Slow Clap for Satie, 1989

TIM ROLLINS
AND K.O.S. (KIDS OF SURVIVAL)
Letter from Birmingham Jail #2 (after the Rev. Dr. M. L. King, Jr.), 2008

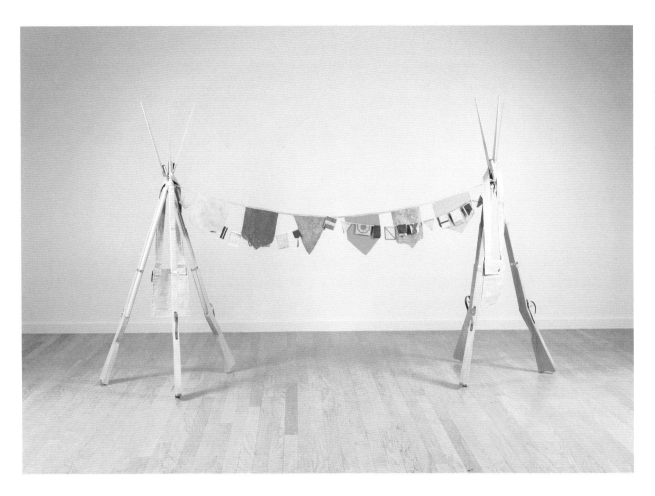

ALLISON SMITH
Our Stack-Arms, 2005-06

AMANDA ROSS-HO
Latticework 2 with Peripheral Disclosure, 2008

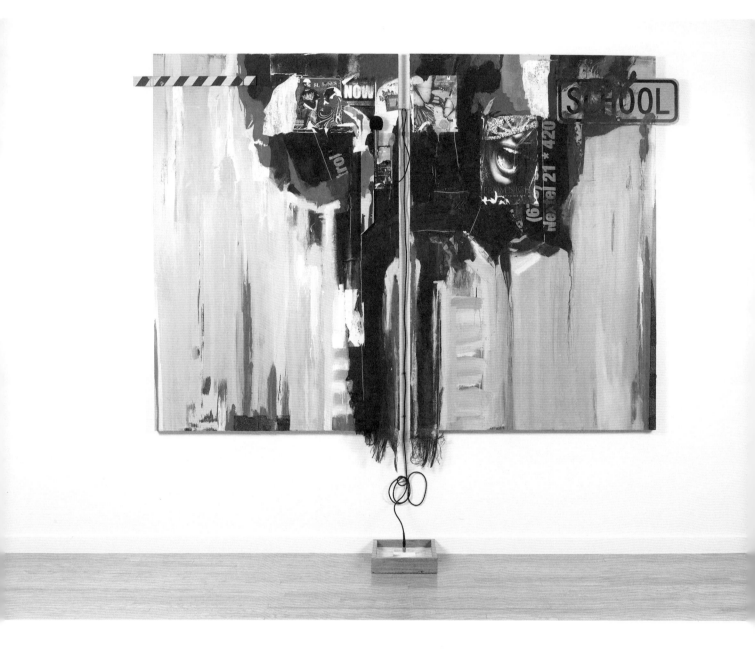

LARRY WALKER

Listen (to da beat), Wall Series (extension with wall spirits), 2008

人民共和動物園
People's Republic of Zoo

SUN XUN
People's Republic of Zoo, 2009

/about the contributors

Wassan Al-Khudhairi is the chief curator at Contemporary Art Museum St. Louis and the former Hugh Kaul Curator of Modern and Contemporary Art at the Birmingham Museum of Art, where she organized *Third Space /shifting conversations about contemporary art*. She was invited to be a curator for the Sixth Asian Art Biennial in Taiwan in 2017 and served as co-artistic director for the Ninth Gwangju Biennial in South Korea in 2012. As the founding director of Mathaf: Arab Museum of Modern Art in Qatar, Al-Khudhairi oversaw the opening of the museum in 2010 and co-curated *Sajjil: A Century of Modern Art* and *Cai Guo-Qiang: Saraab*.

H. G. Masters is editor-at-large of *ArtAsiaPacific* magazine (Hong Kong) and editor of the *ArtAsiaPacific Almanac*, an annual survey of contemporary art in fifty-three countries and territories of the Asia-Pacific region and the Middle East. Previously, he was managing editor of *ArtAsiaPacific*, and was the director of the 2013 Global Art Forum (Doha/Dubai), organized by Art Dubai. Along with contributions to other art publications, including *Frieze, Even*, and *RES Artworld*, he has written catalogue essays on Shinro Ohtake (STPI, Singapore), Ha Chonghyun (Kukje/Tina Kim, Seoul/New York), Lee Mingwei (MCA Sydney), Şener Özmen (Arter, Istanbul), Hajra Waheed (Experimenter, Kolkata), Haegue Yang (STPI), Nuri Kuzucan (Eduoard Malingue, Hong Kong), Vahap Avşar (Rampa, Istanbul), Aslı Cavuşoğlu (Art-ist, Istanbul), Monir Shahroudy Farmanfarmaian (The Third Line, Dubai), and Tsherin Sherpa (Rossi & Rossi, Hong Kong), and for *Tradition Transformed: Contemporary Artists from Tibet* at the Rubin Museum of Art, New York.

Lindsey Reynolds is the Dodd Librarian at the University of Georgia's Lamar Dodd School of Art. She received her MLIS degree from the University of Alabama and her BFA from the University of Georgia. She is interested in how libraries can be generative spaces for practicing artists as well as serving traditional research communities. She previously worked at the Birmingham Museum of Art in Alabama, the Whitney Museum of American Art in New York, and with the New York Art Resources Consortium, which consists of the research libraries of three leading art museums in New York City: the Brooklyn Museum, the Frick Collection, and the Museum of Modern Art. Since 2012, she has been a part of the planning committee for the Contemporary Artists' Book Conference, held in conjunction with the New York Art Book Fair at MoMA PS1.

Based in Chicago, **Ivy G. Wilson** is a writer and cultural critic interested in the relationship between aesthetics and politics, contemporary art of the modern global city, and the practices of transnationalism. He teaches at Northwestern University where he is an affiliate faculty member in the Department of Art, Theory, and Practice. The author of *Specters of Democracy* (Oxford UP), he is currently working on a trio of essays on post-socialist aesthetics, of which a recent feature on The Propeller Group is a part.

/exhibition checklist

All works in the exhibition are copyrighted by the artists. Additional copyright notices are listed with captions.

Derrick Adams
(born 1970 Baltimore, MD, lives and works in Brooklyn, NY)
I Come in Peace, 2014
Mixed media, collage on paper
48 × 72 in. (121.9 × 182.9 cm)
Collection of the Art Fund, Inc. at the Birmingham Museum of Art; Purchase with funds provided by the Collectors Circle for Contemporary Art
AFI.152.2014
p. 57, detail p. 56

Laylah Ali
(born 1968 Buffalo, NY, lives and works in Williamstown, MA)
Presidents, 1994–96
Ink, oil, and pencil on canvasboard
78 × 78 in. (198.1 × 198.1 cm)
Collection of Jim Sokol and Lydia Cheney
T.2016.291.1-.42
p. 168, detail p. 169

Islam Aly
(born 1975 Monufia, Egypt, lives and works in Cedar Falls, IA)
The Square, Al Midan, 2014
From the collection of the Clarence B. Hanson Jr. Library, Birmingham Museum of Art
pp. 170–71

Ghada Amer
(born 1963 Cairo, Egypt, lives and works in New York and Paris)
Les Nains, 2003
Acrylic, embroidery, and gel on canvas
72 × 79 in. (182.9 × 200.7 cm)
Collection of Jim Sokol and Lydia Cheney
T.2016.290
© Ghada Amer. Courtesy Cheim & Read, New York
p. 58

Emma Amos
(born 1938, Atlanta, GA, lives and works in New York, NY)
Measuring, Measuring, 1995
Acrylic on linen canvas, Kente fragment, batiked hand swatches, African strip woven borders, and laser-transfer photographs
84 × 70 in. (213.4 × 177.8 cm)
Museum purchase with funds provided by the Collectors Circle for Contemporary Art and the Traditional Arts Acquisition Fund
2003.35
Art © Emma Amos/Licensed by VAGA, New York, NY
p. 59

Belkis Ayón
(born 1967 Havana, Cuba, died 1999 Havana, Cuba)
Untitled, 1999
Offset lithograph
20 × 27¾ in. (50.8 × 70.5 cm)
Museum purchase with funds provided by the Sankofa Society
2005.99
© Belkis Ayón Estate
p. 60, detail p. 54

Radcliffe Bailey
(born 1968 Bridgeton, NJ, lives and works in Atlanta, GA)
Black Diamond, 2007
Military blankets, wool
130 × 160 in. (330.2 × 406.4 cm)
Collection of the Art Fund, Inc. at the Birmingham Museum of Art; Gift of the Aardt Foundation in honor of Mayor William A. Bell, Sr.
AFI.497.2012a-b
© Radcliffe Bailey. Courtesy of the artist and Jack Shainman Gallery, New York
p. 173, detail p. 172

José Bedia
(born 1959 Havana, Cuba, lives and works in Miami, FL)
Mpangui jimagua (Twin Brothers), 2000
Acrylic and conté on canvas with objects
122 × 355 × 188 in. (309.9 × 901.7 × 477.5 cm)
Museum purchase with funds provided by the Collectors Circle for Contemporary Art in honor of Pauline Ireland
2000.84a-b
p. 175

Dawoud Bey
(born 1953 Queens, NY, lives and works in Chicago, IL)
Don Sledge and Moses Austin, 2012
Archival inkjet prints
40 × 64 in. (101.6 × 81.3 cm)
Museum purchase with funds provided by the Photography Guild, the Collectors Circle for Contemporary Art, the Sankofa Society and others
2013.27a-b
© Dawoud Bey, courtesy Rena Bransten Gallery, San Francisco, and Mary Boone Gallery, New York
p. 179

Dawoud Bey
(born 1953 Queens, NY, lives and works in Chicago, IL)
Taylor Falls and Deborah Hackworth, 2012
Archival inkjet prints
40 × 64 in. (101.6 × 81.3 cm)
Museum purchase with funds provided by the Photography Guild, the Collectors Circle for Contemporary Art, the Sankofa Society and others
2013.26a-b
© Dawoud Bey, courtesy Rena Bransten Gallery, San Francisco, and Mary Boone Gallery, New York
p. 178

Dawoud Bey
(born 1953 Queens, NY, lives and works in Chicago, IL)
Braxton McKinney and Lavone Thomas, 2012
Archival inkjet prints
40 × 64 in. (101.6 × 81.3 cm)
Gift of Rena Bransten Gallery
2013.23a-b
© Dawoud Bey, courtesy Rena Bransten Gallery, San Francisco, and Mary Boone Gallery, New York
p. 177

Dawoud Bey
(born 1953 Queens, NY, lives and works in Chicago, IL)
Mary Parker and Caela Cowan, 2012
Archival inkjet prints
40 × 64 in. (101.6 × 81.3 cm)
Gift of Rena Bransten Gallery
2013.22a-b
© Dawoud Bey, courtesy Rena Bransten Gallery, San Francisco, and Mary Boone Gallery, New York
p. 176

Mark Bradford
(born 1961 Los Angeles, CA, lives
and works in Los Angeles, CA)
As Colors Are Fainting, 2014
Mixed media on canvas
102 × 144 in. (259.1 × 365.8 cm)
Collection of Sheldon Inwentash
and Lynn Factor, Toronto
T.2015.185
© Mark Bradford. Courtesy the
artist and Hauser & Wirth
p. 101, detail p. 100

Kevin Bubriski
(born 1954 North Adams, MA,
lives and works in Vermont)
*Untitled from the New Orleans
series,* 2006
Gelatin silver print
23¾ × 19⅞ in. (60.3 × 50.5 cm)
Gift of John Hagefstration
2006.23
p. 103

Kevin Bubriski
(born 1954 North Adams, MA,
lives and works in Vermont)
*Untitled from the New Orleans
series,* 2006
Gelatin silver print
23⅞ × 19⅞ in. (60.6 × 50.5 cm)
Gift of John Hagefstration
2006.22
p. 102

Nick Cave
(born 1959 Jefferson City, MO,
lives and works in Chicago, IL)
Soundsuit, 2009
Fabric with appliquéd crochet
and buttons, knitted yarn, and
mannequin
96 × 27 × 14 in. (243.8 × 68.6 ×
35.6 cm)
Museum purchase with funds
provided by the Collectors Circle
for Contemporary Art
2010.80
© Nick Cave. Photo by James
Prinz Photography. Courtesy of
the artist and Jack Shainman
Gallery, New York
p. 61, detail p. 4

Enrique Chagoya
(born 1953 Mexico City,
Mexico, lives and works in
San Francisco, CA)
with **Alberto Ríos** (born 1952
Nogales, AZ, lives and works in
Tempe, AZ)
You Are Here, 2000
Lithographs, suite of six prints
17 × 17 in. (43.2 × 43.2 cm) each
Gift of Susie and Scott Robertson
2003.42.1-.6
p. 25, detail p. 24

Sarah Charlesworth
(born 1947 East Orange, NJ,
died 2013 Falls Village, CT)
April 21, 1978, 1978
Black and white prints
As installed 102 ½ × 207 in.
(260.4 × 525.8 cm)
Museum purchase with funds
from the National Endowment for
the Arts and the Members of the
Birmingham Museum of Art
1990.19.1a-ss
© Sarah Charlesworth Estate
p. 27, detail p. 26

Zoë Charlton
(born 1973 Tallahassee, FL, lives
and works in Baltimore, MD)
Cousins 9, 2009
Graphite and gouache on paper
60 × 40 in. (152.4 × 101.6 cm)
Museum purchase with funds
provided by the Sankofa Society:
Friends of African American and
African Art
2012.49
p. 62

Barbara Chase-Riboud
(born 1939 Philadelphia, PA,
lives and works in Paris, France)
She Number One, 1972
Polished bronze, silk
13½ × 26 × 43 in. (34.3 × 66 ×
109.2 cm)
Gift of the Betty Parsons
Foundation
1985.328a-e
© Barbara Chase-Riboud,
courtesy Michael Rosenfeld
Gallery, New York
p. 105

Mel Chin
(born 1951 Houston, TX, lives
and works in Burnsville, NC)
The Sigh of the True Cross,
1988
Pine, olive, ash, mud, steel, ox
gut, and teff
125 × 87 × 26 in. (317.5 × 221 ×
66 cm)
Museum purchase with funds
provided by the National
Endowment for the Arts, a federal
agency, and general acquisition
funds
1990.8
p. 28, detail p. 14

William Christenberry
(born 1936 Tuscaloosa, AL,
died 2016 Washington, DC)
*Corn Sign with Storm Cloud,
Near Greensboro, Alabama,*
Negative 1977; printed 1995
EverColor print
8 × 10 in. (20.3 × 25.4 cm)
Collection of the Art Fund, Inc.
at the Birmingham Museum of
Art; Gift of John Hagefstration
AFI.75.2013
p. 113

William Christenberry
(born 1936 Tuscaloosa, AL,
died 2016 Washington, DC)
*"Bread-of-Life," near Tuscaloosa,
Alabama, June 2001,* 2001
Chromogenic print
8 × 10 in. (20.3 × 25.4 cm)
Gift of Maria and Lee Friedlander
2004.35
p. 112

William Christenberry
(born 1936 Tuscaloosa, AL,
died 2016 Washington, DC)
*Parts, near Tuscaloosa,
Alabama, 1990,* Negative 1990;
printed 1993
Chromogenic print
8 × 10 in. (20.3 × 25.4 cm)
Gift of Maria and Lee Friedlander
2004.20
p. 111

William Christenberry
(born 1936 Tuscaloosa, AL,
died 2016 Washington, DC)
*Storefront, Stewart, Alabama,
1962,* Negative 1962; printed
2001
Chromogenic print
8 × 10 in. (20.3 × 25.4 cm)
Gift of Maria and Lee Friedlander
2004.16
p. 111

William Christenberry

(born 1936 Tuscaloosa, AL,
died 2016 Washington, DC)

Red Trailer, Livingston, Alabama,
1976, Negative 1976; printed
2002

Chromogenic print

8 × 10 in. (20.3 × 25.4 cm)

Gift of Maria and Lee Friedlander

2004.14

p. 110

William Christenberry

(born 1936 Tuscaloosa, AL,
died 2016 Washington, DC)

Processing, Memphis, Tenn.,
1966, 1966; printed 1981

Dye transfer print

11⅛ × 13⅞ in. (28.3 × 35.2 cm)

Gift of Stephen P. Strickland in
honor of Libby Anderson Cater
and Douglass Cater

2002.13.3

p. 109

William Christenberry

(born 1936 Tuscaloosa, AL,
died 2016 Washington, DC)

Fruit Stand, Sidewalk, Memphis,
Tenn., 1966, 1966; printed 1981

Dye transfer print

11 × 14⅛ in. (27.9 × 35.9 cm)

Gift of Stephen P. Strickland
in honor of Alice Jeanne and
George Huddleston, Jr.

2002.13.2

p. 109

William Christenberry

(born 1936 Tuscaloosa, AL,
died 2016 Washington, DC)

"Bread-of-Life," Near
Tuscaloosa, Alabama, 1989

Chromogenic print

20 × 24 in. (50.8 × 61 cm)

Gift of Mr. and Mrs. William
Christenberry

1998.9

p. 108

William Christenberry

(born 1936 Tuscaloosa, AL,
died 2016 Washington, DC)

Railroad Car, Birmingham,
Alabama, 1987

Chromogenic print

20 × 24 in. (50.8 × 61 cm)

Commissioned by *The*
Birmingham News for The
Birmingham News Centennial
Photographic Collection at the
Birmingham Museum of Art

1988.1.5

p. 107

William Christenberry

(born 1936 Tuscaloosa, AL,
died 2016 Washington, DC)

Red Trucks, Birmingham,
Alabama, 1987

Chromogenic print

20 × 24 in. (50.8 × 61 cm)

Commissioned by *The*
Birmingham News for The
Birmingham News Centennial
Photographic Collection at the
Birmingham Museum of Art

1988.1.4

p. 106

William Christenberry

(born 1936 Tuscaloosa, AL,
died 2016 Washington, DC)

Blue Building, Birmingham,
Alabama, 1987

Chromogenic print

20 × 24 in. (50.8 × 61 cm)

Commissioned by *The*
Birmingham News for The
Birmingham News Centennial
Photographic Collection at the
Birmingham Museum of Art

1988.1.2

p. 106

Willie Cole

(born 1955 Somerville, NJ, lives
and works in Mine Hill, NJ)

G.E. Mask and Scarification,
1998

Sandblasted glass and laser print
on two panels with wood shelf

14⁵⁄₁₆ × 22¾ × 2⁹⁄₁₆ in. (36.4 × 57.8
× 6.5 cm)

Museum purchase with funds
provided by David and Natalie
Sperling in honor of their friends
Mr. and Mrs. Stanley Erdreich,
Dr. and Mrs. Robert Walton, Mr.
and Mrs. Edgar Marx, Mrs. Carvel
Woodall, Ms. Anne Silberman, Dr.
and Mrs. Emmett O. Templeton,
Ms. Carole Simpson, Dr. and
Mrs. Jimmie Harvey, Jr., Mr. John
Whitworth, Mr. and Mrs. Harold
Apolinsky, Dr. and Mrs. Robert
T. Russell, Mr. and Mrs. Stanley
Lapidus, Dr. and Mrs. Jim Lasker,
Dr. and Mrs. Jerry Chandler, and
Mr. and Mrs. Robert Loeb

2007.128a-c

© Willie Cole. Courtesy of
Alexander and Bonin,
New York, NY.

p. 29

Willie Cole

(born 1955 Somerville, NJ, lives
and works in Mine Hill, NJ)

Stowage, 1997

Woodblock print on kozo-shi
paper

49⁹⁄₁₆ × 95¹⁄₁₆ in. (125.9 × 241.5 cm)

Gift of Attorney Deborah
Byrd Walker; Jones & Davis,
P.C., Attorneys at Law; One
Hundred Black Men of America,
Birmingham Chapter; Members
of the Birmingham City Council
in recognition of the Members
of the Art Club, Inc., and James
D. Sokol

1999.6

© Willie Cole. Courtesy of
Alexander and Bonin,
New York, NY.

p. 30

Gaby Collins-Fernandez

(born 1987 New York, NY, lives
and works in New York, NY)

Blue velvet wave painting, 2013

Oil and acrylic on crushed velvet

90 × 60 in. (228.6 × 152.4 cm)

Lent by Michael Straus

T.2016.325

p. 114

N. Dash

(born 1980 Miami Beach, FL,
lives and works in New York
and New Mexico)

Untitled, 2016

Adobe; graphite, pigment, acrylic,
gesso, string, canvas, linen, jute,
and wood support

37½ × 69 × 3½ in. (95.3 × 175.3
× 8.9 cm)

Lent by Michael Straus

T.2016.326

Photo: Jean Vong. Courtesy
the artist and Casey Kaplan,
New York

p. 115

Thornton Dial

(born 1928 Emelle, AL, died
2016 McCalla, AL)

Life Bird, 1990

Watercolor on paper

29¾ × 22 in. (75.6 × 55.9 cm)

Lent by Tom L. Larkin

T.2016.312

© Estate of Thornton Dial /
Artists Rights Society (ARS),
New York

p. 119

Thornton Dial

(born 1928 Emelle, AL, died
2016 McCalla, AL)

Lady Holds the Peace Bird, 1990

Watercolor on paper

22⅛ × 30⅛ in. (56.2 × 76.5 cm)

Lent by Tom L. Larkin

T.2016.311

© Estate of Thornton Dial /
Artists Rights Society (ARS),
New York

p. 118

Thornton Dial

(born 1928 Emelle, AL, died
2016 McCalla, AL)
*Lady with her Tiger—Life Go
On,* 1990
Watercolor on paper
22⅛ × 30⅛ in. (56.2 × 76.5 cm)
Lent by Tom L. Larkin
T.2016.310
© Estate of Thornton Dial /
Artists Rights Society (ARS),
New York
p. 117

Thornton Dial

(born 1928 Emelle, AL, died
2016 McCalla, AL)
*Paying Attention—Getting
Hooked,* Undated
Watercolor on paper
29¾ × 22⅛ in. (75.6 × 56.2 cm)
Lent by Tom L. Larkin
T.2016.309
© Estate of Thornton Dial /
Artists Rights Society (ARS),
New York
p. 116

Thornton Dial

(born 1928 Emelle, AL, died
2016 McCalla, AL)
No Right in the Wrong, 1992
Mixed media
60 × 90 in. (152.4 × 228.6 cm)
Lent by Doug McCraw
T.2016.308
© Estate of Thornton Dial /
Artists Rights Society (ARS),
New York
p. 63

Thornton Dial

(born 1928 Emelle, AL, died
2016 McCalla, AL)
Big Fish Eat All the Little Fish,
About 1983
Acrylic, metal, and foam on board
48 × 67 × 2 in. (121.9 × 170.2 ×
5.1 cm)
Museum purchase with funds
provided by the Birmingham
Regional Arts Commission and
general acquisition funds
2000.5
© Estate of Thornton Dial / Artists
Rights Society (ARS), New York
p. 31

William Downs

(born 1974 Greenville, SC, lives
and works in Atlanta, GA)
I will wait another day, 2015
From the collection of the
Clarence B. Hanson Jr. Library,
Birmingham Museum of Art
p. 32

David C. Driskell

(born 1931 Eatonton, GA,
lives and works in Hyattsville,
MD, Falmouth, ME, and
New York, NY)
Ghetto Wall #1, 1971
Oil and collage on canvas
39½ × 35¼ in. (100.3 × 98.7 cm)
Gift of the 1972 Festival of the
Arts and A. G. Gaston Purchase
Award
1972.8
p. 180, detail p. 88

Melvin Edwards

(born 1937 Houston, TX, lives
and works in Upstate New York
and Plainfield, NJ)
*Premonition from the Lynch
Fragment Series,* 1990
Welded steel
18¼ × 11 × 11 in. (46.4 × 27.9 ×
27.9 cm)
Museum purchase with funds
provided by the National
Endowment for the Arts, a federal
agency, and the Junior Patrons of
the Birmingham Museum of Art
1991.802
p. 181

William Eggleston

(born 1939 Memphis, TN, lives
and works in Memphis, TN)
Untitled, 1983
Chromogenic print
42 × 31½ in. (106.7 × 80 cm)
Collection of the Art Fund, Inc. at
the Birmingham Museum of Art;
Gift of John Hagefstration
AFI.191.2015
© Eggleston Artistic Trust.
Courtesy Cheim & Read,
New York
p. 123

William Eggleston

(born 1939 Memphis, TN, lives
and works in Memphis, TN)
Untitled, 1981–82
Chromogenic print
17 × 14 in. (43.2 × 35.6 cm)
Museum purchase
1986.219.3
© Eggleston Artistic Trust.
Courtesy Cheim & Read,
New York
p. 122

William Eggleston

(born 1939 Memphis, TN, lives
and works in Memphis, TN)
Untitled, 1981–82
Chromogenic print
14 × 17 in. (35.6 × 43.2 cm)
Museum purchase
1986.219.2
© Eggleston Artistic Trust.
Courtesy Cheim & Read,
New York
p. 121

William Eggleston

(born 1939 Memphis, TN, lives
and works in Memphis, TN)
Untitled, 1981–82
Chromogenic print
14 × 17 in. (35.6 × 43.2 cm)
Museum purchase
1986.219.1
© Eggleston Artistic Trust.
Courtesy Cheim & Read,
New York
p. 120

Skylar Fein

(born 1968 New York, NY, lives
and works in New Orleans, LA)
See You at the UpStairs Lounge,
from *Remember the UpStairs
Lounge,* First edition 2008; this
edition 2009
Latex on wood
50 × 48 × 3 in. (127 × 121.9 ×
7.6 cm)
Museum purchase in honor of
Scott Miller with funds provided
by Mr. and Mrs. Stanley Erdreich,
Jr., Mr. Jim Sokol and Ms. Lydia
Cheney, Mr. Edgar Marx, Jr.,
Mr. and Mrs. Brian G. Giattina,
Ms. Amy Pleasant, and Ms. Gail
Andrews
2009.1
p. 64

Colette Fu

(born 1969 Princeton, NJ, lives
and works in Philadelphia, PA)
*Yi Costume Festival from the
series We Are the Tiger Dragon
People,* 2008–13
From the collection of the
Clarence B. Hanson Jr. Library,
Birmingham Museum of Art
p. 125, detail p. 124

Phyllis Galembo

(born 1952 New York, NY, lives
and works in New York, NY)
*Fancy Dress and Rasta, Nobles
Masquerade Group, Winneba,
Ghana,* 2009
Chromogenic print
61⅞ × 61⅜ in. (157.2 × 155.9 cm)
Museum purchase with funds
provided by the Photography
Guild
2013.3
p. 65

Tomoo Gokita

(born 1969 Tokyo, Japan, lives
and works in Tokyo, Japan)
Be Just Like Family, 2015
Acrylic gouache on linen
76 × 102 in. (193 × 259.1 cm)
Lent by the Bjørnholt Collection,
Oslo
T.2016.328
© Tomoo Gokita, courtesy Bill
Brady Gallery, Miami, and Mary
Boone Gallery, New York
p. 182

Fred Hagstrom

(born 1954 Minneapolis, MN,
lives and works in St. Paul, MN)
Passage, 2013
From the collection of the
Clarence B. Hanson Jr. Library,
Birmingham Museum of Art
p. 33

Hassan Hajjaj

(born 1961 Larache, Morocco,
lives and works in London, UK,
and Marrakech, Morocco)
Brown Eyes, 2010
Lambda print on Dibond
52 × 34 in. (132.1 × 86.4 cm)
Lent by Michael Straus
T.2016.323
p. 67

Hassan Hajjaj

(born 1961 Larache, Morocco,
lives and works in London, UK,
and Marrakech, Morocco)
Ya Amina, 2006
Digital c-type on Fuji crystal
archive paper
42 × 33 in. (106.7 × 83.8 cm)
Lent by Jack and Rebecca Drake
T.2016.317
p. 66

Lonnie Holley

(born 1950 Birmingham, AL,
lives and works in Atlanta, GA)
*The Pointer Pointing the Way
of Life on Earth,* 1997
Painted prefabricated concrete
lawn sculpture, cloth, tree limb,
chain, plastic water bottle, paper,
cotton, and polypropylene
44 × 28 × 30 in. (111.8 × 71.1 ×
76.2 cm)
Museum purchase
2004.105
p. 68

Lonnie Holley

(born 1950 Birmingham, AL,
lives and works in Atlanta, GA)
Mystery of the White in Me,
1983
Pigmented sandstone
13¾ × 10½ × 3½ in. (34.9 × 26.7
× 8.9 cm)
Gift of Mr. and Mrs. Jack
McSpadden
1984.22
p. 126, detail p. 127

Merritt Johnson

(born 1977 Baltimore, MD, lives
and works in Portland, OR)
*Crow booming the One Big
Water, Gulls flying away,* 2010
Oil and alkyd on panel
36 × 48 in. (91.4 × 121.9 cm)
Collection of the Art Fund, Inc.
at the Birmingham Museum of
Art; Gift of the artist
AFI.462.2012
p. 186, detail p. 166

Chris Jordan

(born 1963 San Francisco, CA,
lives and works in Seattle, WA)
*Globe in Classroom, Chalmette
Neighborhood,* 2005
Inkjet print
29½ × 34¼ in. (74.9 × 87 cm)
Lent by Michel Straus
T.2016.322
p. 131, detail p. 98

Chris Jordan

(born 1963 San Francisco, CA,
lives and works in Seattle, WA)
Dollar Store near Buras, LA,
2005
Inkjet print
29½ × 34¼ in. (74.9 × 87 cm)
Lent by Michel Straus
T.2016.321
p. 131

Chris Jordan

(born 1963 San Francisco, CA,
lives and works in Seattle, WA)
*Sand & Gravel Yard, New
Orleans,* 2005
Inkjet print
44½ × 91½ in. (113 × 232.4 cm)
Lent by Michel Straus
T.2016.320
p. 130

Chris Jordan

(born 1963 San Francisco, CA,
lives and works in Seattle, WA)
Circuit Boards, Atlanta 2004,
2004
Inkjet print
44 × 66 in. (111.8 × 167.6 cm)
Lent by Michel Straus
T.2016.319
p. 129

Chris Jordan

(born 1963 San Francisco, CA,
lives and works in Seattle, WA)
Cell Phones, Orlando 2004, 2004
Inkjet print
43¾ × 83¾ in. (111.1 × 207.6 cm)
Museum purchase with funds
provided by John Hagefstration
and the Photography Guild
2005.23
p. 128

Glenn Kaino

(born 1972 Los Angeles, CA, lives
and works in Los Angeles, CA)
Bridge (Section 1 of 6), 2014
Fiberglass, steel wire, and gold
paint
28 × 36 in. (71.1 × 91.4 cm),
height variable
Collection of the Art Fund, Inc. at
the Birmingham Museum of Art;
Purchase with funds provided by
members of the Collectors Circle
for Contemporary Art
AFI.6.2016
© Glenn Kaino. Courtesy Honor
Fraser Gallery
p. 69

El Franco Lee II
(born 1979 Houston, TX, lives
and works in Houston, TX)
Nightmare Katrina 2, 2006
Acrylic on canvas
30 × 40 in. (76.2 × 101.6 cm)
Lent by Jack and Rebecca Drake
T.2016.318
p. 35, detail p. 34

Glenn Ligon
(born 1960 Bronx, NY, lives
and works in New York, NY)
Runaways, 1993
Ten lithographs
15½ × 11½ in. (39.4 × 29.2 cm)
each
Museum purchase
2001.286.1-.10
© Glenn Ligon. Courtesy of
the artist, Luhring Augustine,
New York, Regen Projects, Los
Angeles, and Thomas Dane
Gallery, London
pp. 132–33

Larissa Lockshin
(born 1992 Toronto, Canada,
lives and works in New York, NY)
Untitled (Reviewer), 2015
Soft pastel and oil stick on satin
on canvas
60½ × 48½ in. (153.7 × 123.2 cm)
Lent by Michel Straus
T.2016.324
p. 134

Whitfield Lovell
(born 1959 Bronx, New York,
lives and works in New York, NY)
Rise of the Delta, 2013
Conté on wood, silver-plated
platters, penny, and wrought iron
sconce
98 × 63 × 11 in. (248.9 × 160 ×
27.9 cm)
Lent by Norman and Carnetta
Davis
T.2016.327
© Whitfield Lovell. Courtesy of
DC Moore Gallery, New York
p. 184

Sally Mann
(born 1951 Lexington, VA, lives
and works in Lexington, VA)
Untitled, About 1998
Gelatin silver print
20 × 24 in. (50.8 × 61 cm)
Museum purchase
2009.9.4
© Sally Mann. Courtesy Gagosian
p. 135

Sally Mann
(born 1951 Lexington, VA, lives
and works in Lexington, VA)
Arundo Donax, 1988
Gelatin silver print
20 × 24 in. (50.8 × 61 cm)
Museum purchase with funds
provided by the Harriet Murray
Endowment Fund
1991.732
© Sally Mann. Courtesy Gagosian
p. 135

Kerry James Marshall
(born 1955 Birmingham, AL,
lives and works in Chicago, IL)
As Seen on TV, 2002
Enamel on plastic vase, plastic
flowers, framed video still, wood
and glass shelf with steel bracket
and chain
98 × 32 × 7 in. (248.9 × 18.3 ×
17.8 cm)
Collection of the Art Fund, Inc. at
the Birmingham Museum of Art;
Gift of Jack Drake
AFI.1.2007.1-.3
© Kerry James Marshall.
Courtesy of Kerry James Marshall
and Jack Shainman Gallery, NY
p. 185

Susan Meiselas
(born 1948 Baltimore, MD, lives
and works in New York, NY)
Traditional Indian dance mask
from the town of Monimbo,
adopted by the rebels during the
fight against Somoza to conceal
identity (from "Nicaragua, June
1978–July 1979"), 1981
Cibachrome print
20 × 16 in. (50.8 × 40.6 cm)
Museum purchase with funds
provided by the Photography
Guild
1991.856
Susan Meiselas/Magnum Photos
p. 70

Beatriz Milhazes
(born 1960 Rio de Janeiro, Brazil,
lives and works in Rio de Janeiro,
Brazil)
A Infanta, 1996
Acrylic on canvas
44½ × 63 in. (113 × 160 cm)
Gift of Ruth and Marvin Engel
and their friends and family in
honor of their 50th wedding
anniversary
1998.66
p. 136

Abelardo Morell
(born 1948 Havana, Cuba, lives
and works in Boston, MA)
Camera Obscura Image of
El Vedado, Habana, Looking
Northwest, Cuba, 2002
Gelatin silver print
50 × 60 in. (127 × 152.4 cm)
Museum purchase with funds
provided by the Photography
Guild
2010.8
© Abelardo Morell/Courtesy
Edwynn Houk Gallery, New York
& Zürich
p. 137, detail p. 46

Odili Donald Odita
(born 1966 Enugu, Nigeria, lives
and works in Philadelphia, PA)
Gravity's Rainbow, 2001
Acrylic on canvas
70 × 84 in. (177.8 × 213.4 cm)
Purchase in memory of Iain
MacPherson Alexander by
docents, friend of the Collectors
Circle for Contemporary Art, and
Margaret, Brendan and Bruce
Alexander
2002.138
p. 139, detail p. 138

Toyin Ojih Odutola
(born 1985 Ile-Ife, Nigeria, lives
and works in New York, NY)
Hank, 2012
Pen, ink, and marker on paper
11⅞ × 9 in. (30.2 × 22.9 cm)
Museum purchase with funds
provided by Ruth and Marvin
Engel in honor of William Njogu
2013.1
© Toyin Ojih Odutola. Courtesy
of the artist and Jack Shainman
Gallery, New York
p. 71

Demetrius Oliver
(born 1975 Brooklyn, NY, lives
and works in New York, NY)
Hearth, 2006
Digital C-print
33 × 48 in. (83.8 × 121.9 cm)
Lent by Jack and Rebecca Drake
T.2016.316
Courtesy of the artist and Inman
Gallery
p. 75

Demetrius Oliver
(born 1975 Brooklyn, NY, lives
and works in New York, NY)
Seminole, 2004
Digital C-print
33 × 42 in. (83.8 × 106.7 cm)
Lent by Jack and Rebecca Drake
T.2016.315
Courtesy of the artist and Inman
Gallery
p. 74

Demetrius Oliver
(born 1975 Brooklyn, NY, lives
and works in New York, NY)
Tracks, 2003–05
Digital C-print
28⅛ × 36 in. (71.4 × 91.4 cm)
Collection of the Art Fund, Inc.
at the Birmingham Museum of
Art; Jack Drake Collection of
Contemporary Art
AFI.95.2011
Courtesy of the artist and Inman
Gallery
p. 72, detail p. 73

Dennis Oppenheim
(born 1938 Electric City, WA,
died 2011 New York, NY)
Slow Clap for Satie, 1989
Acrylic, wood, steel, motors,
ficus trees, pots, turntables,
vacuum formed masks, and loop
recording of Erik Satie piano
music
Approximately 120 × 240 ×
240 in. (304.9 × 609.8 × 609.8 cm)
Gift of Dennis Oppenheim
1998.58a-g
p. 187

Gordon Parks
(born 1912 Fort Scott, KS,
died 2006 New York, NY)
*Store Front, Mobile, Alabama,
1956,* 1956
Pigment print
20 × 16 in. (50.8 × 40.6 cm)
Collection of the Art Fund, Inc. at
the Birmingham Museum of Art
AFI.898.2012.12
Courtesy of and copyright The
Gordon Parks Foundation
p. 143

Gordon Parks
(born 1912 Fort Scott, KS,
died 2006 New York, NY)
*Mother and Children, Mobile,
Alabama, 1956,* 1956
Pigment print
20 × 16 in. (50.8 × 40.6 cm)
Collection of the Art Fund, Inc. at
the Birmingham Museum of Art
AFI.898.2012.10
Courtesy of and copyright The
Gordon Parks Foundation
p. 143

Gordon Parks
(born 1912 Fort Scott, KS,
died 2006 New York, NY)
*At Segregated Drinking
Fountain, Mobile, Alabama,
1956,* 1956
Pigment print
20 × 16 in. (50.8 × 40.6 cm)
Collection of the Art Fund, Inc. at
the Birmingham Museum of Art
AFI.898.2012.9
Courtesy of and copyright The
Gordon Parks Foundation
p. 143

Gordon Parks
(born 1912 Fort Scott, KS, died
2006 New York, NY)
*Black Classroom, Shady Grove,
Alabama, 1956,* 1956
Pigment print
20 × 16 in. (50.8 × 40.6 cm)
Collection of the Art Fund, Inc. at
the Birmingham Museum of Art
AFI.898.2012.6
Courtesy of and copyright The
Gordon Parks Foundation
p. 142

Gordon Parks
(born 1912 Fort Scott, KS,
died 2006 New York, NY)
Untitled, Shady Grove, 1956,
1956
Pigment print
20 × 16 in. (50.8 × 40.6 cm)
Collection of the Art Fund, Inc. at
the Birmingham Museum of Art
AFI.898.2012.5
Courtesy of and copyright The
Gordon Parks Foundation
p. 141

Gordon Parks
(born 1912 Fort Scott, KS,
died 2006 New York, NY)
Untitled, Mobile, 1956, 1956
Pigment print
20 × 16 in. (50.8 × 40.6 cm)
Collection of the Art Fund, Inc. at
the Birmingham Museum of Art
AFI.898.2012.4
Courtesy of and copyright The
Gordon Parks Foundation
p. 141

Gordon Parks
(born 1912 Fort Scott, KS, died
2006 New York, NY)
*Mr. and Mrs. Albert Thornton,
Mobile, Alabama, 1956,* 1956
Pigment print
20 × 16 in. (50.8 × 40.6 cm)
Collection of the Art Fund, Inc. at
the Birmingham Museum of Art
AFI.898.2012.3
Courtesy of and copyright The
Gordon Parks Foundation
p. 141

Gordon Parks
(born 1912 Fort Scott, KS,
died 2006 New York, NY)
*Children at Play, Mobile,
Alabama, 1956,* 1956
Pigment print
20 × 16 in. (50.8 × 40.6 cm)
Collection of the Art Fund, Inc. at
the Birmingham Museum of Art
AFI.898.2012.2
Courtesy of and copyright The
Gordon Parks Foundation
p. 140

Ebony G. Patterson
(born 1981 Kingston, Jamaica,
lives and works in Kingston,
Jamaica, and Lexington, KY)
*among the weeds, plants, and
peacock feathers,* 2014
Mixed media on jacquard
tapestry with handmade shoes
and crocheted leaves
103 × 133 × 18 in. (261.6 × 337.8
× 45.7 cm)
Collection of the Art Fund, Inc. at
the Birmingham Museum of Art;
Purchase with funds provided
by the Collectors Circle for
Contemporary Art
AFI.150.2015a-e
p. 77, detail p. 76

Jefferson Pinder

(born 1970 Washington, DC, lives and works in Chicago, IL)

Sean (Mercy Seat) from the Juke Series, 2006

Digital video with sound, duration 4 mins, 32 secs

Collection of the Art Fund, Inc. at the Birmingham Museum of Art; Gift of the Jack and Rebecca Drake Collection

AFI.23.2012

p. 78

Annie Pootoogook

(born 1969 Cape Dorset, Nunavut, Canada, died 2016 Ottawa, Ontario, Canada)

Untitled, 2006

Crayon and ink on paper

20 × 26 in. (50.8 × 66 cm)

Collection of the Art Fund, Inc. at the Birmingham Museum of Art; Purchase with funds provided by Guy R. Kreusch

AFI.182.2013

p. 79

Michael Rakowitz

(born 1973 Great Neck, NY, lives and works in Chicago, IL)

Sabreen: Live in Jerusalem 2010, 2014

From the collection of the Clarence B. Hanson Jr. Library, Birmingham Museum of Art

p. 36

Marc Robinson

(born 1972, Los Angeles, CA, lives and works in Brooklyn, NY)

Untitled (Malcolm × and Heart Fragment), 2008

Screenprint and printed glass fragment

30 × 24 in. (76.2 × 61 cm)

Anonymous gift in honor of Orlando V. Thompson II

AFI.102.2016

p. 80

Tim Rollins

(born 1955 Pittsfield, ME, lives and works in Bronx, NY) and

K.O.S. (Kids of Survival)

Letter from Birmingham Jail #2 (after the Rev. Dr. M. L. King, Jr.), 2008

Matte acrylic and book pages on canvas

70⅛ × 90 in. (178.1 × 228.6 cm)

Collection of the Art Fund, Inc. at the Birmingham Museum of Art; Purchase with funds provided by John and Nancy Poynor

AFI.27.2015

Courtesy Studio K.O.S., Lehmann Maupin, New York and Hong Kong

p. 188, detail p. 189

Tim Rollins

(born 1955 Pittsfield, ME, lives and works in Bronx, NY) and

K.O.S. (Kids of Survival)

Invisible Man (after Ralph Ellison), 1999–2000

Acrylic and book pages on linen

75 × 75 in. (190.5 × 190.5 cm)

Collection of the Art Fund, Inc. at the Birmingham Museum of Art; Gift of Pauline Ireland in loving memory of her mother, Jeannette Adams Gates

AFI.185.2011

Courtesy Studio K.O.S., Lehmann Maupin, New York and Hong Kong

p. 183

Amanda Ross-Ho

(born 1975 Chicago, IL, lives and works in Los Angeles, CA)

Latticework 2 with Peripheral Disclosure, 2008

Wooden trellis, wicker chair, framed Lightjet print, ceramic goblet, sneakers, gold chain, canvas, spray paint, and sequins

96 × 48 × 31 in. (243.8 × 121.9 × 78.7 cm)

Museum purchase with funds provided by Mr. and Mrs. T. Alan Ritchie

2009.63a-g

p. 190

David Salle

(born 1952 Norman, OK, lives and works in New York, NY)

Making the Bed, 1985

Oil, acrylic, and wood on canvas

120 × 98 × 3¾ in. (304.8 × 248.9 × 9.5 cm)

Collection of the Art Fund, Inc. at the Birmingham Museum of Art; Gift of an anonymous donor

AFI.14.2004a-b

Art © David Salle/Licensed by VAGA, New York, NY

p. 37

Esterio Segura

(born 1970 Santiago de Cuba, Cuba, lives and works in Havana, Cuba)

La historia se muerde la cola (History Bites its Tail), 2013

Painted fiberglass

47¼ × 15¾ × 15¾ in. (120 × 40 × 40 cm)

Collection of Jim Sokol and Lydia Cheney

T.2016.292

p. 38, detail p. 22

Cindy Sherman

(born 1954 Glen Ridge, NJ, lives and works in New York, NY)

Untitled #213, 1989

Chromogenic color print

41½ × 33 in. (105.4 × 83.8 cm)

Museum purchase with funds provided by the Acquisitions Fund and Rena Hill Selfe

1990.15

© Cindy Sherman. Courtesy of the Artist and Metro Pictures

p. 81

Katrín Sigurdardóttir

(born 1967 Reykjavik, Iceland, lives and works in New York, NY)

2nd Floor (784 Columbus Ave), 2003

Modeling wood (birch and basswood scale lumber) and paint

4 × 75 × 26 in. (10.2 × 190.5 × 66 cm)

Collection of the Art Fund, Inc. at the Birmingham Museum of Art; Gift of an anonymous donor

AFI.11.2011

Photo by Travis Fullerton

p. 39

Lorna Simpson

(born 1960 Brooklyn, NY, lives and works in Brooklyn, NY)

Tense, 1991

Gelatin silver prints and plastic

65 × 123 in. (165.1 × 312.4 cm)

Museum purchase with funds provided by the Dorsky Foundation and the General Acquisition Fund

2001.47.1-.8

© Lorna Simpson, Courtesy the artist and Hauser & Wirth

p. 144

Allison Smith
(born 1972 Manassas, VA,
lives and works in New York, NY)
Our Stack-Arms, 2005-06
Wood, aluminum, painted
canvas, hand-sewn linen, carved
wooden rifles with bayonets,
linen pouches, painted pennants,
and cord
70 × 117 × 36 in. (177.8 × 297.2
× 91.4 cm)
Collection of the Art Fund, Inc. at
the Birmingham Museum of Art;
Gift of Scott and Kelly Miller
AFI.1.2016.1-.6
p. 191

Tabaimo
(born 1975 Hyogo, Japan, lives
and works in Nagano, Japan)
Sutra and Child's Leg, 2003
Lithograph
23⅝ × 16½ in. (60 × 41.9 cm)
Museum purchase with funds
provided by the Collectors Circle
for Contemporary Art
2005.72
p. 147

Tabaimo
(born 1975 Hyogo, Japan, lives
and works in Nagano, Japan)
*Raise Your Flags and Walk Along
the Pedestrian Crossing,* 2003
Lithograph
23⅝ × 16½ in. (60 × 41.9 cm)
Museum purchase with funds
provided by the Collectors Circle
for Contemporary Art
2005.71
p. 147

Tabaimo
(born 1975 Hyogo, Japan, lives
and works in Nagano, Japan)
Men's Bathhouse, 2003
Lithograph
16½ × 23⅝ in. (41.9 × 60 cm)
Museum purchase with funds
provided by the Collectors Circle
for Contemporary Art
2005.70
p. 146

Tabaimo
(born 1975 Hyogo, Japan, lives
and works in Nagano, Japan)
Railway Track, 2003
Lithograph
16½ × 23⅝ in. (41.9 × 60 cm)
Museum purchase with funds
provided by the Collectors Circle
for Contemporary Art
2005.69
p. 146

Hank Willis Thomas
(born 1976 Plainfield, NJ, lives
and works in New York, NY)
Jermaine and Logan, 2002;
printed 2006
Lightjet print
29¾ × 24 in. (75.6 × 61 cm)
Collection of the Art Fund, Inc.
at the Birmingham Museum
of Art; Jack Drake Collection
of Contemporary Art
AFI.94.2011
Courtesy Hank Willis Thomas
and Jack Shainman Gallery, NY
p. 83

Hank Willis Thomas
(born 1976 Plainfield, NJ, lives
and works in New York, NY)
Priceless, 2005
Inkjet print on vinyl
173 × 214½ in. (439.4 × 544.8 cm)
Collection of the Art Fund, Inc.
at the Birmingham Museum of
Art; Gift of the Jack and Rebecca
Drake Collection
AFI.1.2017
Courtesy Hank Willis Thomas
and Jack Shainman Gallery, NY
p. 82

Mickalene Thomas
(born 1971 Camden, NJ, lives
and works in New York, NY)
*Do What Makes You Satisfied
(from the She Works Hard for
the Money series),* 2006
Rhinestones, acrylic, and enamel
on wood
36 × 48 in. (91.4 × 121.9 cm)
Collection of the Art Fund, Inc.
at the Birmingham Museum of
Art; Jack Drake Collection of
Contemporary Art
AFI.109.2011
p. 84, detail p. 85

Torey Thornton
(born 1990 Macon, GA, lives
and works in Brooklyn, NY)
Time Lapsed Lapping, 2015
Acrylic, spray paint, chalk pastel,
graphite, nail polish, glue, crayon,
and collage on wood panel
58 × 64 in. (147.3 × 162.6 cm)
Lent by Margaret and Bruce
Alexander
T.2016.313
Courtesy of the artist and Moran
Bondaroff, Los Angeles
p. 148

Mose Tolliver
(born 1920 Pike Road, AL,
died 2006 Montgomery, AL)
Dry Bones, About 1984
Paint on wood board
24 × 18¼ in. (61 × 46.4 cm)
Collection of the Art Fund, Inc. at
the Birmingham Museum of Art;
Robert Cargo Folk Art Collection;
Gift of Caroline Cargo
AFI.330.2013
© 2017 Estate of Mose Tolliver/
Artists Rights Society (ARS),
New York
p. 41

Mose Tolliver
(born 1920 Pike Road, AL, died
2006 Montgomery, AL)
Dry Bones, 1985
Paint on wood board
25 × 13 in. (63.5 × 33 cm)
Collection of the Art Fund, Inc. at
the Birmingham Museum of Art;
Robert Cargo Folk Art Collection;
Gift of Caroline Cargo
AFI.329.2013
© 2017 Estate of Mose Tolliver/
Artists Rights Society (ARS),
New York
p. 40

Mose Tolliver
(born 1920 Pike Road, AL,
died 2006 Montgomery, AL)
Dry Bones, 1985
Paint on wood board
23½ × 15 in. (59.7 × 38.1 cm)
Collection of the Art Fund, Inc. at
the Birmingham Museum of Art;
Robert Cargo Folk Art Collection;
Gift of Caroline Cargo
AFI.328.2013
© 2017 Estate of Mose Tolliver/
Artists Rights Society (ARS),
New York
p. 40

Juan Uslé

(born 1954 Santander, Spain, lives and works in New York and Spain)

Zozobras en el Jardín (Rumors in the Garden), 1999

Vinyl, dispersion, and pigment on canvas

80 × 108 in. (203.2 × 274.3 cm)

Museum purchase with funds provided by the Collectors Circle for Contemporary Art

1999.57

© Juan Uslé. Courtesy Cheim & Read, New York

p. 149

Melissa Vandenberg

(born 1977 Detroit, MI, lives and works in Richmond, KY)

Come Undone, 2012

Mixed media

26½ × 26½ in. (67.3 × 67.3 cm)

Lent by Karen and Joel Piassick

T.2016.314

p. 43

Xavier Vendrell, Steve Long, Rural Studio, Auburn University

2x's, 2016

Southern pine

127½ × 120 × 168½ in. (323.9 × 304.8 × 428 cm)

Structure: Joe Farruggia

Collaborators: Olivia Backer, Carlie Chastain, Anna Daley, Chelsea Elcott, Mary English, Jake LaBarre, Jenny Lomas, Ben Malaier, Janine Mwenja, Tim Smela, John Sydnor, Alex Therrien, Grant Wright

Courtesy of the artists

T.2016.393

p. 151, detail p. 8

Kara Walker

(born 1969 Stockton, CA, lives and works in New York, NY)

Freedom: A Fable, 1997

Bound volume of offset lithographs and five laser-cut, pop-up silhouettes on wove paper

From the collection of the Clarence B. Hanson Jr. Library, Birmingham Museum of Art

Artwork © Kara Walker, courtesy of Sikkema Jenkins & Co., New York

p. 152

Larry Walker

(born 1935 Franklin, GA, lives and works in Atlanta, GA)

Listen (to da beat), Wall Series (extension with wall spirits), 2008

Mixed materials and microphone and sandbox

93½ × 106¼ × 17⅛ in. (237.5 × 269.9 × 43.5 cm)

Collection of the Art Fund, Inc. at the Birmingham Museum of Art; Purchase with funds provided by Corbin Day

AFI.99.2016a-g

p. 192

Carrie Mae Weems

(born 1953 Portland, OR, lives and works in Syracuse, NY)

The Tragedy of Hiroshima, 2008

Archival pigment print

40 × 40 in. (101.6 × 101.6 cm)

Collection of the Art Fund, Inc. at the Birmingham Museum of Art; Gift of Lydia C. Cheney and James D. Sokol

AFI.214.2013

© Carrie Mae Weems. Courtesy of the artist and Jack Shainman Gallery, New York

p. 153

Mary Whitfield

(born 1947 Birmingham, AL, lives and works in Port Washington, NY)

Love, 1991–94

Watercolor and acrylic on canvas board

15½ × 19⅜ in. (39.4 × 49.2 cm)

Gift of the artist

1994.111

Courtesy Phyllis Stigliano Art Projects

p. 154

Sue Williamson

(born 1941 Lichfield, England, lives and works in Cape Town, South Africa)

Mementoes of District Six, 1993

Various objects preserved in Lucite, Plexiglas, steel, rubble, South African soil, lights, and sound

88½ × 60 × 60 in. (224.8 × 152.4 × 152.4 cm)

Museum purchase with funds provided by the Collectors Circle for Contemporary Art

1993.53a-f

p. 86

Fred Wilson

(born 1954 Bronx, New York, lives and works in New York, NY)

Old Salem: A Family of Strangers, 1995

Color photographs

20¼ × 16¼ in. (51.4 × 41.3 cm) each

Co-owned by Birmingham Museum of Art and Memphis Brooks Museum of Art (Series One exhibited). Museum purchase in honor of David Moos, former Curator of Modern and Contemporary Art at the Birmingham Museum of Art, with funds provided by Lydia Cheney and Jim Sokol, Russell Jackson Drake, Howard Greenberg, Mr. and Mrs. Edgar Marx Sr. and Edgar Marx Jr., John and Nancy Poynor, Amasa Smith Jr., Robin and Carolyn Wade, Julie and Jeff Ward, and members of the Collectors Circle for Contemporary Art

2005.15.1-.10

© Fred Wilson, courtesy Pace Gallery. Photograph by Jim Frank, courtesy the Neuberger Museum of Art

p. 44

Wilmer Wilson IV

(born 1989 Richmond, VA, lives and works in Philadelphia, PA)

Black Mask, 2012

Digital video, 6 minutes

Collection of the Art Fund, Inc. at the Birmingham Museum of Art; Purchase with funds provided by Lydia Cheney and Jim Sokol; Judge and Mrs. Ralph Cook, C. Rene' Myers, Brandon and Michelle Hewitt, and Rebecca and Jack Drake

AFI.13.2013

© Wilmer Wilson IV, Courtesy of CONNERSMITH, Washington, DC

p. 87

Sun Xun

(born 1980 Fuxin, China, lives
and works in Beijing, China)
People's Republic of Zoo, 2009
Digital video animation with
sound, 7 mins, 49 secs
Museum purchase with funds
provided by the Collectors Circle
for Contemporary Art
2011.34
pp. 194–95

Purvis Young

(born 1943 Miami, FL, died
2010 Miami, FL)
Burial Over the City, About 1990
Oil on board
48⅜ × 47¼ in. (122.9 × 120 cm)
Gift of Dr. Kurt Gitter and Alice
Rae Yelen
1995.78
p. 155

Artists' Books

Clara Balaguer

(born 1980 Manila, Philippines,
lives and works in City of
Parañaque, Manila, Philippines)
Filipino Folk Foundry (2nd
Edition), 2015
From the collection of the
Clarence B. Hanson Jr. Library,
Birmingham Museum of Art
p. 161

Wes Frazer

(born 1978 Birmingham, AL, lives
and works in Birmingham, AL)
The Black Belt, 2013–15
From the collection of the
Clarence B. Hanson Jr. Library,
Birmingham Museum of Art
p. 161

Trenton Doyle Hancock

(born 1974 Oklahoma City, OK,
lives and works in Houston, TX)
Me a Mound, Published 2005
From the collection of the
Clarence B. Hanson Jr. Library,
Birmingham Museum of Art
p. 162

Lonnie Holley

(born 1950 Birmingham, AL, lives
and works in Atlanta, GA)
Keeping a Record of It, 2013
From the collection of the
Clarence B. Hanson Jr. Library,
Birmingham Museum of Art
p. 162

Lonnie Holley

(born 1950 Birmingham, AL,
lives and works in Atlanta, GA)
Just Before Music, 2013
From the collection of the
Clarence B. Hanson Jr. Library,
Birmingham Museum of Art
p. 162

Ruth Laxson

(born 1924 Roanoke, AL, lives
and works in Atlanta, GA)
A Hundred Years of: LEX FLEX,
2003
From the collection of the
Clarence B. Hanson Jr. Library,
Birmingham Museum of Art
p. 163

Burgin Mathews

(born 1977 Montgomery, AL, lives
and works in Birmingham, AL)
Thirty Birmingham Songs, 2011
From the collection of the
Clarence B. Hanson Jr. Library,
Birmingham Museum of Art
p. 163

Burgin Mathews

(born 1977 Montgomery, AL, lives
and works in Birmingham, AL)
*Reverend Mister Gate Mouth:
The One Who Buried Sin / The
Death & Life of "Gatemouth"
Moore,* 2013
From the collection of the
Clarence B. Hanson Jr. Library,
Birmingham Museum of Art
p. 163

Burgin Mathews

(born 1977 Montgomery, AL, lives
and works in Birmingham, AL)
*LIVE! At the Alabama Women's
Prison / Mack Vickery & The
Julia Tutwiler Blues,* 2014
From the collection of the
Clarence B. Hanson Jr. Library,
Birmingham Museum of Art
p. 163

Jessica Peterson

(born 1976 Rochester, NY, lives
and works in New Orleans, LA)
*An Homage to the Divas of the
Aisles of Kymberlyn Compare
Foods Grocery,* 2004
From the collection of the
Clarence B. Hanson Jr. Library,
Birmingham Museum of Art
p. 163

David Sandlin

(born 1956 Belfast, Northern
Ireland, lives and works in New
York, NY)
*Land of 1000 Beers: Travel
Guide to La Via Dollarosa,* 1989
From the collection of the
Clarence B. Hanson Jr. Library,
Birmingham Museum of Art
p. 164, detail p. 156

Peter Schumann

(born 1934 Silesia, Poland, lives
and works in Glover, VT)
*The Fiddle Sermons from the
Insurrection Masses with
Funeral Marches for Rotten
Ideas,* 1999
From the collection of the
Clarence B. Hanson Jr. Library,
Birmingham Museum of Art
p. 165

Peter Schumann

(born 1934 Silesia, Poland,
lives and works in Glover, VT)
The Foot, 2002
From the collection of the
Clarence B. Hanson Jr. Library,
Birmingham Museum of Art
p. 165

Our thanks to these galleries and
institutions for assistance with
catalogue images:
Alexander and Bonin, New York
Artists Rights Society, New York
Bill Brady Gallery, Miami
Cheim & Read, New York
James Cohan Gallery, New York
DC Moore Gallery, New York
Feheley Fine Arts, Toronto,
 Canada
The Gordon Parks Foundation
Honor Fraser Gallery, Los Angeles
Inman Gallery, Houston
Luhring Augustine, New York
Monique Meloche Gallery,
 Chicago
Metro Pictures, New York
Regen Projects, Los Angeles
Michael Rosenfeld Gallery,
 New York
Jack Shainman Gallery, New York
Phyllis Stigliano Art Projects,
Brooklyn, New York
ShangART Gallery, Shanghai,
 China
Souls Grown Deep Foundation,
 Atlanta
Tilton Gallery, New York
VAGA, New York

This book is published in conjunction with the exhibition *Third Space: Shifting Conversations about Contemporary Art* at the Birmingham Museum of Art, January 28, 2017–January 6, 2019.

Funding was provided by PNC, Community Foundation of Greater Birmingham, Protective Life Foundation, and Vulcan Materials Company Foundation. Additional support provided by numerous foundations and private donors. Catalogue support provided by Robert Rauschenberg Foundation.

Library of Congress Control Number: 2017954527
ISBN-13: 978-1-934774-17-5
ISBN-10: 1-934774-17-0

Published by the Birmingham Museum of Art
2000 Rev. Abraham Woods Jr. Blvd.
Birmingham, AL 35203
www.artsbma.org

Distributed by ARTBOOK | D.A.P.
75 Broad Street, Suite 630
New York, NY 10004
www.artbook.com

Produced by Lucia | Marquand, Seattle
www.luciamarquand.com

Edited by Mariah Keller
Designed by Meghann Ney
Typeset in AGM and Unica by Integrated Composition Systems
Proofread by Ted Gilley
Color management by iocolor, Seattle
Printed and bound in China by Artron Art Group
Photography by M. Sean Pathasema unless otherwise noted